D1625667

Nagasaki Prints
and
Early Copperplates

Masanobu Hosono

translated and adapted by

Lloyd R. Craighill

Distributed in the United States by Kodansha International/U.S.A. Ltd., through Harper & Row Publishers, Inc., 10 East 53rd Street, New York, New York 10022; in Europe by Boxer-books Inc., Limmatstrasse 111, 8031 Zurich; and in Japan by Kodansha International Ltd., 2-12-21 Otowa, Bunkyo-ku, Tokyo 112.

Nagasaki Prints and Early Copperplates was originally published in Japanese by the Shibundo publishing company, Tokyo, 1969, under the title *Yōfūhanga*, as volume 36 in the series *Nihon no bijutsu*. The English edition was prepared at Kodansha International, Tokyo, by Saburo Nobuki, Takako Suzuki, and Michael Brase.

Published by Kodansha International Ltd., 2-12-21 Otowa, Bunkyo-ku, Tokyo 112 and Kodansha International/USA Ltd., 10 East 53rd Street, New York, New York, 10022 and 44 Montgomery Street, San Francisco, California 94104. Copyright © 1978 by Kodansha International Ltd. and Shibundo. All rights reserved. Printed in Japan.

Hosono, Masanobu
 Nagasaki prints and early copperplates.

 (Japanese arts library; v. 6)
 Translation of Yōfūhanga.
 Bibliography: p.
 Includes index.
 1. Color prints, Japanese—Japan—Nagasaki.
2. Color prints, Japanese—Edo period, 1600–1868.
3. Color prints, Japanese—Meiji period, 1868–
1912. 4. Color prints, Japanese—Occidental
influences, I. Title. II. Series.
NE772.N33H6713 769'.952 77–75972
ISBN 0–87011–311–9

HERTFORDSHIRE
LIBRARY SERVICE
769.952
9028335

NOV 1978

First edition, 1978 JBC 1371-786007-2361

CONTENTS

Japanese Art Periods

Prehistoric		−537
Asuka		538–644
Nara		645–781
Hakuhō	645–710	
Tempyō	711–81	
Heian		782–1184
Jōgan	782–897	
Fujiwara	898–1184	
Kamakura		1185–1332
Nambokuchō		1333–91
Muromachi		1392–1572
*Momoyama		1573–99
*Edo		1600–1867

Note: This table has been provided by the Agency
for Cultural Affairs of the Japanese Government.
Periods marked with an asterisk are described in
the Glossary.

ILLUSTRATIONS

A Note to the Reader

Japanese names are given in the customary Japanese order, surname preceding given name.

INTRODUCTION

When, in 1871, the newly established central government of Japan dispatched its foreign minister, Iwakura Tomomi, to the United States and Europe on a mission of diplomacy and inquiry, the total number of diplomats and other observers in the mission came to nearly a hundred people, including many of the top leaders of the nation, and their composite report ran to five large volumes. Only eighteen years prior to this event Japan had been under such rigorous edicts of seclusion, enforced by her feudal masters, that normal relations with the rest of the world had been cut off for two and a half centuries, and a violation of the seclusion policy was punishable by death. When these walls of seclusion were toppled by the arrival of Commodore Perry and his American warships in Japanese waters in 1853 and 1854, the course of Japan's destiny underwent the dramatic change suggested by the juxtaposition of these two national attitudes.

Japan's sudden openness to Western ways was indeed anticipated by a limited number of Japanese specialists in European civilization, a group of sometimes brave and often lonely students of the world beyond the barrier. Their resoluteness and knowledge comprised one of the elements in the social revolution known as the Meiji Restoration, a revolution which eventually brought Japan to its present position of eminence.

In this study Mr. Hosono has produced an account of this process of discovery as reflected in the visual arts, specifically the world of prints and etchings. He traces the pursuit of Western learning and its manifestations in art in order not only to examine the immediate consequences, but also to cast light on the subsequent results—the internationalization of Japanese art. Mr. Hosono welcomes this internationalization and salutes the enterprise and daring of its forerunners.

The first contributors to the broadening of Japan's artistic vision were Spanish and Portuguese missionaries and traders. After their expulsion and the enforcement of the first edicts of seclusion, only a few licensed Dutch traders confined to the port of Nagasaki remained to represent European culture, but these traders made available the books written in Dutch and the European engravings that inspired the first students of Western art and civilization.

The first attempts at printmaking in the Western style using Western techniques were crude and may look out of place in a country that had raised the native technique of block printing to a remarkable level of technical and artistic development. Within a generation, however, these scholars and experimenters were producing etchings and engravings imbued with vitality and distinction, and if Aōdō Denzen's vision of a German city square adorned with Roman temples and monuments seems distinctly adulatory, it can be equated with the fantasies of eighteenth-century European chinoiserie. Furthermore, even before the termination of Japan's seclusion, Western-style perspective principles and other stylistic devices were being assimilated by professional illustrators and landscapists such as Hokusai and Hiroshige, who otherwise stood squarely within the conventions of Sino-Japanese tradition. It was, in fact, partly for this unrecognized reason that Western collectors found these landscape prints so intelligible and appealing. The internationalization of some genres of Japanese art was thus already well under way before the arrival of Perry's "black ships" off Uraga beach.

Mr. Hosono's interpretation of this process has been carefully translated, but additional explanatory material has been inserted, where appropriate, for the benefit of Western readers. Also, his Japanese text assumes a rather high level of familiarity with Japanese history, and details which could only be confusing to most Western readers have been omitted. The translator must assume responsibility for these adaptations.

The translator wishes to express special thanks to the author, Mr. Hosono, for his assistance in identifying the original spellings of European names rendered in Japanese phonetic script. The translator is also greatly indebted to John Rosenfield and Louise Cort for editorial assistance in the early stages of manuscript preparation. Finally, he wishes to thank his wife, Mary Nute Craighill, for her typing and editorial help.

Lloyd R. Craighill

NAGASAKI PRINTS AND EARLY COPPERPLATES

1

THE NEW AND DIFFERENT

The French diplomat and poet Paul Claudel, who was first assigned to Japan in 1912, was to write in later years, in his *Impressions of Japan,* that the Japanese readily "extol and readily disdain things which they do not comprehend." We also find that the French art critic Elie Faure, who collaborated with a group of like-minded Japanese scholars in publishing a journal of critical opinion, wrote in this publication in 1931, "Japan is attempting to learn techniques from Europe, in a broad manner of speaking, but she is not absorbing any additional encumbrances. . . . The absorption of these techniques moves in accordance with the demands of some national trait or native instinct, and it is, in fact, through just this process that an extension of Japanese civilization can be discerned."

However one considers these interpretations, the Japanese themselves are well aware of the fact that Japanese civilization has always been based on the acceptance, assimilation, and development of foreign cultural influences. Before they were aware of the Western world the Japanese were interacting with the continental civilizations of India, China, and Korea, and after Japan became aware of the West the Japanese virtually abandoned themselves to a fascination with things from the other hemisphere.

As instances of continental borrowings one could cite the influence of China's T'ang dynasty on the eighth-century Nara period, the Sung dynasty influences on the arts of the late Heian and Kamakura periods of the twelfth, thirteenth, and fourteenth centuries, and the cultural influences of Ming and Ch'ing China on the Muromachi and Edo periods of the mid-fourteenth through mid-nineteenth centuries. As examples of the phases of Western influence one could cite the arts of the "southern barbarians" (primarily Portuguese missionaries and traders), who came in contact with Japan during the second half of the sixteenth century, and the arts of the "red hairs" (Dutch traders), who first penetrated Japan in the seventeenth century, as well as the impact of French painting in the late nineteenth and early twentieth centuries and Japan's postwar openness to the arts of America, France, Italy, and other Western countries.

These cultural influences, however, especially in the area of the visual arts, did not result in the formation of particular schools, but remained fragmentary and sporadic, sometimes producing a blend of styles of very different temporal origin. One after

another, waves of cultural influence were brought to Japan as though by the monsoon winds, creating, in turn, new stylistic currents as they impinged on these remote shores.

Needless to say, these influences produced great changes and disruptions, moving downward from the privileged ranks of the nobility and the military class to the bourgeoisie, who constituted such a notable element of the society of the Edo period (1600–1867). The city-dwelling commoners of the Edo period had a distinctive vivacity about them, and the repressions of the feudal system and the seclusionist foreign policy of their feudal overlords (the shogunate) made them all the more intent on peering through the single window on the outside world provided by the Dutch trading post in Nagasaki. What might be regarded as a traditional veneration of things foreign was actually identical with this craving for the new and different—really a practical desire for information. Men motivated by this agile and enterprising curiosity made their way to Nagasaki and transmitted their findings to the nation as a whole.

In the realm of the arts, if one were to name the schools that were baptized, or indirectly influenced, by the Western art of the Nagasaki traders, the list would include the Ōbaku school of Zen painting, the Nampin school of Chinese-style realistic bird and flower painting, the Nagasaki-based Western-style print designers, the literati or *bunjin* painters, the school of the Kyoto painter Maruyama Ōkyo, and the *ukiyo* or "floating world" school. Only a few major schools continued without detectable Western influence—the Kanō school favored by the shogunate, the courtly Tosa school and its Sumiyoshi branch, the decorative *rimpa* school, and the conservative *yamato-e* school; this fact alone suggests the great importance of the European influence. Also, when one recognizes the common qualities of realism and naturalism that can be seen as a product of this infusion, one can detect an underlying current drawing Japan toward the modern world of the nineteenth and twentieth centuries.

Of course, as Elie Faure has indicated, this process was largely a matter of methods and techniques, rather than anything prompted by ideology. Some Japanese, however, began to approach a spirit of scientific enquiry, rationalism, and representational realism in art that were characteristically European. The artists who made the steadiest progress toward achieving these ideals were the Western-style artists and especially the print designers, as their works clearly show. The Kanō artists and the *yamato-e* school, which were attached to the feudal authorities and the Imperial Palace, worked from copybooks, and their art gradually lapsed into stylistic formalism. In contrast to this exhaustion of artistic innovation on the part of the official painter, the Western-style print designers were excited by the possibilities inherent in the European style, aware of the limitations of East Asian art (doubtless with some prejudice), and eager to forge ahead with invention and vigor.

This book deals with prints that have been influenced stylistically by the West. The term "Western-style prints" suggests to most people the work of such late nineteenth-century pioneers as Kobayashi Kiyochika and such twentieth-century artists as Oda Kazuma and Yamamoto Kanae, who first labeled their work *sōsaku hanga*

("original" or "creative" prints) on the principle that the designer should carve his own blocks and pull his own impressions. This book, however, deals with the Western-style prints of an earlier age. Included here are woodcuts such as "Nagasaki prints," "view-box" prints, and perspective or "floating" prints, but primary attention is given to the first Japanese copperplates, their principal themes, techniques, and styles—their development through the ongoing absorption of influences from Europe and the role that this development has played in the history of Japanese art.

2

THE SOUTHERN BARBARIANS

The importation of Western culture to Japan can be divided into four periods. The first extends approximately one hundred years from the arrival of the first Portuguese ship at the island of Tanegashima, south of Kyushu, in 1543, and the consequent introduction of European firearms, to the fifth national seclusion proclamation of 1639, which totally banned Portuguese ships from Japanese waters and strictly enjoined a policy of national isolation.

The second period would be the century and a half of gradual consolidation of Western learning—called *rangaku*, "Dutch studies," or *kōmō bunka*, "red-hair learning" —that took place between the shogun Yoshimune's repeal of the ban on Western books, announced in 1720 (books on Christianity were still excluded), and the demise of the Tokugawa military government, the shogunate, in 1867. The third period would be that following the Meiji Restoration of 1868, in which a complete reversal of Japan's seclusion policies was brought about. The fourth would be the period following World War II.

In general, the first two periods, during which the basic Japanese outlook was molded by Chinese civilization, were times of fascination with the strange, when the Portuguese and the Spanish were labeled "southern barbarians" and the Dutch "red hairs"; a steady inflow of things European met a variety of scientific and utilitarian needs, and fads developed for such exotica as *tenshō* playing cards (see pl. 1). The second two periods witnessed more direct and unqualified concentration on Western civilization.

Even during the eight decades between the full establishment of the Tokugawa shogunate's seclusion policy and Yoshimune's relaxation of the ban on Western books, an interval of apparent total isolation, the government permitted regulated trade with China and Holland, since these countries were not insistent on missionary endeavors. During this time, interest in Western medical science, history, and astronomy actually increased. Also, in the realm of Western-influenced art, the Ōbaku branch of Zen Buddhism arrived from China bringing its special emphasis on the painting of realistic portraits of Ōbaku patriarchs, which in turn was associated with the establishment of the Chinese-style school of the Nagasaki-born painter Watanabe Shūseki (1639–1707).

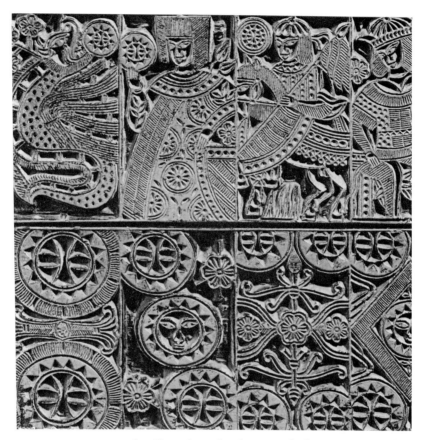

1. Nest of wooden boxes made from carved printing
blocks originally used in the production of Western-style
playing cards. Detail. Each box approx. h. 6.4, w. 3.5 cm.
Sixteenth century. Kobe City Museum of Namban Art.

2–4. *A Dutch Mission Paying Obeisance.* Details. Hand-scroll. Ink and colors on paper. H. 29, l. 355 cm. Tokyo National Museum.

In the year 1649 the Dutch physician Caspar Schambergen arrived in Japan and journeyed to Edo on a tribute mission to the shogun Ietsuna, presenting him with a copy of a book about Holland. In 1665 the director of the Dutch trading post in Nagasaki, Hendrick Indijck, on a similar tribute mission, presented Ietsuna with the Dutch translation of a book on animals by the seventeenth-century naturalist John Johnston and a book on herbal medicine by the Dutch botanist Rembertus Dodoneus. The availability of this sort of information had a great influence on later-day Japanese botanists, Western-style painters, and specialists in the kind of knowledge that was only available to people who could read books in Dutch. A student of Schambergen's by the name of Kobayashi Yoshinobu was the first to begin the serious study of Western history, and Kobayashi's student Nishikawa Joken produced the first geography of Japan, in 1695. A German physician, employed in the Dutch company, by the name of Engelbert Kaempfer (1651–1716), went on tribute missions to the shogun Tsunayoshi in 1691 and 1692, and wrote up his impressions of what went on in the great castle of the shoguns in the city of Edo (now Tokyo) and of the processions of the feudal lords he saw on the way. The scene in the shogun's "throne room" is described as follows in Kaempfer's *History of Japan*, published in 1716:

They [the Lord of Settsu and two attendants] cried out in a loud voice "Oranda

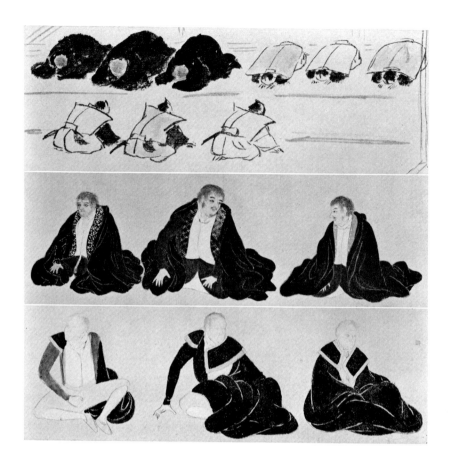

"Kapitan!" This was a signal for him to approach and prostrate himself. Accordingly, he crawled on his hands and knees to a place shown him, between the presents ranged in due order on one side and the place where the emperor [a mistaken reference to the shogun] sat on the other, and there, kneeling, he bowed his forehead all the way down to the floor and so crawled backward like a crab, without uttering a single word.

Plates 2–4 reproduce the appearance of one of these tribute missions, that of Jan Cock Blomhoff. Although there is the saying that when one is in Rome one should do as the Romans do, these Dutch traders' underlying attitude toward Japan is expressed in the description of Holland's worldwide trading enterprises by the Dutch poet Joost van den Vondel: "Profits have led us to every sea and every shore, and for the love of profit we have sounded the harbors of the world."

The interpreter who accompanied the 1692 tribute mission described by Kaempfer was named Motoki Ryōi. He had already accompanied a Dutch tribute mission to Edo in 1682 and had been presented with a symbolic golden bow by the shogun Tsunayoshi. Thus, many decades after the establishment of a thoroughgoing seclusion policy Japan's leaders were still subject to the stimulus of contacts with European civilization, however intermittent and indirect the process.

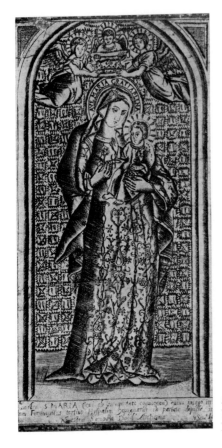

5. *Virgin and Child;* produced at a Japanese seminary by Western missionaries. Copperplate engraving. H. 22, w. 14.5 cm. 1597. Ōura Tenshu-dō, Nagasaki.

The intermediaries were hereditary professional interpreters from such families as the Nishi, Shizuki, and Namura, who followed the Dutch traders from their original post on the island of Hirado to their subsequent location of Deshima, the artificial island built to keep the Dutch contained in Nagasaki harbor. These interpreters bridged the gulf of cultural isolation that separated Japan from the Western world, and they later made an important contribution to "Dutch studies" as well. They were, indeed, the pivotal point for the development of that second phase of cultural infusion from the West, the age of "red-hair learning."

The Protestant Hollanders exerted, of course, a different influence from that of the Portuguese who had preceded them, but even after the Shimabara rebellion of 1637–38, the last stand of the Japanese Catholic converts, Christians continued to worship secretly the "God within the doors" and images of the Virgin disguised as the Bodhisattva Kannon. The persistence of the faith was evidenced by the ongoing issuance of proclamations against missionary activities, and the deportation of 3,400 "hidden Christians" as late as 1867.

As for the fine arts during the first phase of Western contact, the Jesuit missionary Francis Xavier entered Kagoshima Bay in a junk and presented the lord of Satsuma, Shimazu Takahisa, with an oil painting of the Virgin, much to the delight of the daimyo's lady. Also, in the year 1590 four young envoys to the Vatican returned to Japan bringing with them a printing press and a world atlas with copperplate maps by the Flemish cartographer Abraham Ortelius (1527–98), who, in 1595, was to produce the first map of Japan. From this machine Japan's first book in movable type was produced: *Santosu no gosagyō no uchi nukigaki.* The title page reads, "Excerpts from the Lives of the Saints, Volume 1, Hizen Province, Takagi County. Printed with the permission of the superior of the college of the Society of Jesus in Kazasa, in the year of our Lord, 1591." The illustrations are printed from engraved plates. A copy of this work is preserved at Oxford University.

At the Catholic church Ōura Tenshu-dō in Nagasaki is preserved a copper engraving of the Virgin and Child, dated 1597, which notes in Latin at the bottom that it was produced at a Japanese seminary (pl. 5). This work is based on a similar engraving by Hieronimus Wierx (1553–1619) produced at the Cathedral of Seville. (Incidently, a Chinese publication of this period also includes a comparable woodcut of the same subject, this one based on a painting by Martin de Vos [c. 1531–1603] that was copied in an engraving by Antoine Wiertz, another contemporary.) The Japanese seminaries at this time, which were restricted to functioning as study centers for foreigners owing to political strife and the limitations on religious teaching already enacted, appear to have served as centers for the secret printing and distribution of religious materials. This image of the Virgin, printed in Japan by foreigners, expresses a moving quality of simplicity and compassion.

The medicine, astronomy, calendar science, navigation, and cartography that had accompanied the Portuguese to the East became deeply rooted in Japanese soil with the help of books in Chinese translation, which were produced by Catholic missionaries in China and continued to be brought to Japan. Having once been visualized, the possibilities of applying scientific methodology became firmly established in the minds of the forefathers of the present-day Japanese people, along with their briefly glimpsed vision of a strange civilization beyond the seas. The flame lit by the "southern barbarians" did not die out. Before long it was to illuminate many new contributions coming from Holland.

3

FOREIGN CULTURE
AND THE PORT OF NAGASAKI

THE TOWN'S EARLY DEVELOPMENT

In the early days when Nagasaki was variously known as Tamanotsu, Fukutominotsu, and Fukaetsu, it was nothing more than a remote fishing village. The name "Nagasaki" was derived from the feudal family that held dominion over it, though the domain was confiscated by the ruling general Hideyoshi in the late sixteenth century in punishment for insubordination. This forsaken little harbor town was opened to foreign trade in 1571 because it offered the promise of excellent protection to the missionaries and traders who sought a snug anchorage well sheltered from monsoon winds. At this time Christian communities were developing in other northern Kyushu localities such as Hirado, Shimabara, Ōmura, Tonoura, and Yokoseura.

The Jesuits made a special effort to convert the feudal lords of Kyushu with an eye to Kyushu's geographical importance for trade with Spain and Portugal, and the choice of ports was determined by missionaries in Japan who were familiar with Japan's domestic economy. Since Nagasaki was developing a growing Christian community it was accorded special attention. The Shimazus of Satsuma and the Matsuuras of Hizen tended more and more to make a distinction between evangelism and trade, but the daimyo Ōmura Sumitada, eager to gain an advantage in his power struggle with the other lords of Kyushu, decided to encourage missionary activities in his domain, and his harbor town of Yokoseura was the first to be opened to European trade, in 1562. He gave the land for a church and special privileges to the traders, and he himself received baptism, taking the Christian name of Bartolomeo. He was the first of the Christian daimyo, and a substantial number of men of similar rank were to follow his lead. Many of these must have been attracted to the faith for other than commercial reasons, and doubtless there was a reaction against the code of the warrior that had prevailed during the many centuries of civil war.

In 1615 the population of Nagasaki was 25,000, but by 1689 it had shot up to 65,000. The population of Japan at the beginning of the seventeenth century is estimated at eighteen million, using figures of agricultural production as a basis, while by 1723 it had reached about thirty million, according to the shogun Yoshimune's census of that year. Thus the nation's population increased by about two-thirds in 120 years.

Compared to this, Nagasaki's population almost tripled during only seventy-three years of this period, indicating the importance Nagasaki was acquiring as a commercial center.

The shogun Ieyasu issued an edict of prohibition against Christianity in 1612, and thereafter his government opposed the spread of Christianity and forced the separation of commercial and religious activities. One hundred and forty-eight Christians, including the general Takayama Ukon, were banished to Manila and Macao, and after 1626 the testing of Christian suspects by forcing them to trample on a Christian image was put into regular practice by order of the shogun Iemitsu. In 1634 a command issued to the magistrates of Nagasaki ordered them to build the little artificial island of Deshima just off the Nagasaki quay, and to incarcerate all Portuguese on the island (pl. 6; bottom right). Ships licensed for foreign trade had their licenses revoked, the repatriation of overseas Japanese was forbidden, and even the entry of ships from China was restricted.

The last organized stand to be made by Japanese Christians, the Shimabara revolt of 1637–38, was put down with the assistance of a Dutch warship whose Protestant captain did not object to firing on Catholic converts. This revolt graphically reminded the shogunal authorities of the intensity of the converts' loyalty to their faith. Finally, the entry of all Portuguese ships was banned in the following year. The buildings thus vacated on Deshima were later used to house the only remaining Europeans, the Dutch traders of Hirado, whose transfer was ordered in 1641. In 1651 the Chinese of Nagasaki were relocated in a special settlement, a move said to have been prompted by the desire to keep Chinese Christians under surveillance. When China was experiencing the collapse of the Ming dynasty, the Chinese court petitioned Japan on two occasions for reinforcements, a sad decline from the dynasty's previous pride and power. The Chinese of Nagasaki, in their isolated abodes, were sequestered representatives of a crumbling regime, and there was little for them to do but lose themselves in commercial activities.

ART FROM ACROSS THE SEAS

Perhaps because of the sense of isolation imposed by these new restrictions, people in Japan crowded to their one window on the world represented by the Dutch and Chinese trading communities in Nagasaki, and avidly pursued their interest in foreign cultures. Despite the mood of conservatism and disengagement implied by the seclusion policy, Nagasaki was a hive of bustling activity. The Portuguese had been banished in an irrevocable policy decision, but the Dutch and the Chinese were quick to fill the void. The allowable volume of trade was set at six thousand bars of silver for the Chinese and three thousand for the Dutch, and their activities were strictly limited to Nagasaki.

New trends in the visual arts were also introduced exclusively through Nagasaki.

27

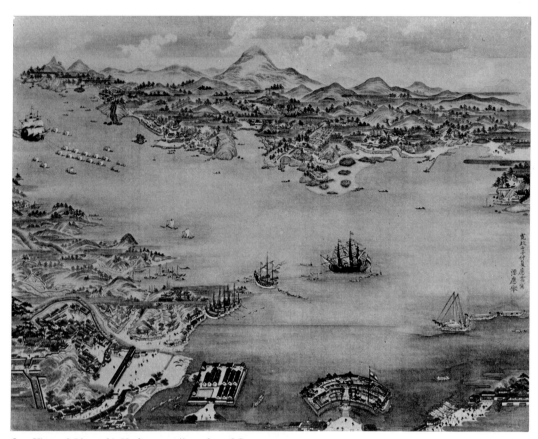

6. *View of Nagasaki Harbor;* attributed to Maruyama
Ōkyo. Ink and colors on silk. H. 80, w. 99 cm. 1792.
Nagasaki Prefectural Art Museum.

The Ming-dynasty monk and missionary for the Ōbaku sect of Zen Buddhism, I-jan, arrived in Nagasaki in 1644. He had studied painting under the Zen master Yin-yüan, whom he invited, with his disciples, to Nagasaki in 1654. The realistic style of the *chinsō* portraits of the Ōbaku sect had been influenced by contact with the Jesuit mission in Peking, following the arrival of the great missionary priest Mateo Ricci. The use of shading in the delineation of features produced a verisimilitude that startled the Japanese when they first saw it. Although Buddhist monk painters were arriving in great numbers from China, the importation of paintings and scrolls in the Chinese style had been forbidden. The edict specified that the Dutch were not to bring in Chinese paintings either. But the Nagasaki painters Kita Sōun and Kita Genki received personal instruction from the Chinese Ōbaku monks. They did paintings of patriarchs for other sects as well, and the quality of their portraiture was excellent. In the Nagasaki office of the shogunal administration, the newly created position of supervisor of Chinese-style paintings was filled in 1697 by Watanabe Shūseki, who had studied under I-jan, followed by Hirowatari Ikko in 1699. The duty of these officials was to examine the artistic imports that were now coming from China, and to catalogue and copy them, in the course of which they became true painters in their own right. Both artists established families that inherited these official functions in succeeding generations. Later the position also fell to the houses of Ishizaki (1736) and Araki (1766). In the 1790s the painter Wakasugi Isohachi developed a competence in the Western technique of oil painting, and in the 1820s Kawahara Keiga pursued a similar interest. He took a position as resident painter to the Dutch colony on Deshima, entering the employ of the German physician Philipp Franz von Siebold, and under his direction produced many paintings from nature. It seems that Kawahara Keiga also received instruction from the illustrator Carolus Hubert de Villeneuve, who came to Nagasaki at von Siebold's request.

The Japanese were equally fascinated by the "Nampin" school of the visiting artists Ch'en Nan-p'in and Sung Tzu-shih, whose popularity spread from Nagasaki to all parts of Japan. Nan-p'in visited Nagasaki only from 1731 to 1733, but his strong use of color and his illusionistic avoidance of linear elements produced a fresh, decorative quality that was welcomed throughout Japan. Other examples of this style could be found in the work of Hsiung-fei and Sung Tsu-shan.

In 1720 the shogun Yoshimune relaxed the ban on the importation of Western art and literature that was unrelated to Christianity, and the result was not only a booming growth in "Dutch studies" but also greatly expanded research into the techniques of copperplate printing and oil painting. Among those who became fascinated with these techniques were Hiraga Gennai, Odano Naotake, Satake Shozan, Shiba Kōkan, and Aōdō Denzen. In 1722 Yoshimune asked the leader of the Dutch traders in Nagasaki for an oil painting, and the result was the arrival and gift of a painting of flowers in an urn by the Dutch artist Willem van Royen, painted in 1725. It was later donated to the temple Gohyakurakan-ji in Edo (modern Tokyo), where it was copied by the

Ishikawa brothers Tairō and Mōkō, and by the eclectic scholar-painter Tani Bunchō. The copy done by the Ishikawa brothers bears an appreciative inscription by the "Dutch studies" scholar Ōtsuki Bansui (pls. 7–8). The mysterious appeal of naturalistic representation in oil painting spurred many Japanese painters up until the time of the Meiji Restoration to conduct difficult experiments.

These new techniques and sources of information continued to be dispersed from Nagasaki to all parts of Japan. Nagasaki stood for change and enterprise, and it should come as no surprise that the popular and elegant multicolored "brocade print" or *nishiki-e* of Edo met with competition from the distinctive "Nagasaki print." These prints, with their depictions of the strange ways of the foreigners, served as coveted souvenirs for travelers who managed to reach this far western outpost of the country. The *ukiyo-e* or "floating world" prints of Edo dealt with such limited subjects as the ladies of the gay quarters, kabuki actors, and *sumō* wrestlers, but Nagasaki prints, although stylistically influenced by Western art, were engagingly artless in execution and varied in subject. These delightful depictions of people from the unreachable lands beyond the seas continued to be sold to curious and avid collectors until the Townsend Harris treaty of amity and commerce in 1858 suddenly deprived Nagasaki of its special status.

New information about the Western world was brought to Edo, the shogunal capital, when the administrators of the Dutch settlement made their regular tribute missions to Edo Castle. These trips—166 altogether—occurred on the average twice every three years and rather resembled the tribute missions required of all the lords of daimyo rank. The effect of the journeys was to let the light of European civilization shine in the shogunal capital, and in time the presence of these Dutchmen was to undermine the very basis of the seclusion policy itself. Nagasaki was the loophole in the barrier of seclusion, a town with a Christian history, and the nation's one center for international commerce and the study of European civilization. In the midst of inward-turning conservatism, Nagasaki held high the banner of progress.

寛政丙辰冬至

磐水

大槻茂質識

實可謂奪造化之工矣以余修西學畫或之後使余題其子於上余展開之把玩不惜稱賛之餘書以應其需云爾

宛然若堂名園之中而馥郁芬襲人衣袖也嗟寫生之巧

詣寺請住持僧相與摹之後東五日而卒業是圖也花草之形菓菰之狀以至禽鳥昆蛾之文色澤逼真位置極精緻爛陵離

士也善畫兼巧西洋畫法今第孟高君市巧画兄弟相謀一日

方魯伊覽者所圖也源今兹両辰七十有一年矣石川君好事

德廟所檀施云考施中文大西洋一千七百二十五年微兒列模

掛幅両軸中第一圖所摸寫也本圖蓋

此薫松軒石川君以江戸本所羅漢寺興嚴藏阿蘭陀油繪花鳥

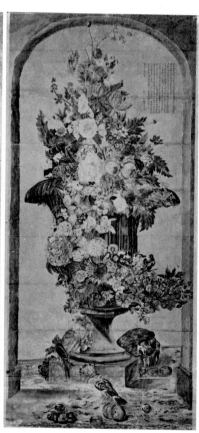

7–8. *Flowers in an Urn*, by Mōkō and Tairō Ishikawa. Copy of a painting by Willem van Royen. Encomium by Ōtsuki Bansui. Ink and colors on paper. H. 233, w. 107 cm. 1796. Private collection, Japan.

4

NAGASAKI WOODBLOCK PRINTS

ORIGINS

The origins of the distinctive prints produced in Nagasaki can be traced back to as early as 1645. These origins are to be found in two pictures, now in the Kobe City Museum of Namban Art, called *A Depiction of All the Peoples of the World* and *A Map of All the Nations of the World* (pls. 9–10). The 1645 date can be discerned on the former, with some assistance from the inscription on a later reproduction. Starting in the upper right-hand corner with Japan, followed by China, a man and a woman are represented from forty-two nations of the world. The black lines in the picture were block printed, but the colors are tempera, added by brush. The map of the world is actually a painted copy, but its identical dimensions and complementary subject matter imply that the original print would have been a companion piece to the print of the peoples of the world. From subject matter and style it can also be inferred that these would have been block-print versions of a pair of companion folding screens of the *namban* ("southern barbarian") genre. Judging by their stylistic derivation from the Portuguese-inspired *namban* art of a half-century earlier, these pictures (or the original, in the case of the map) would seem to be the oldest examples of that Europe-oriented genre known as the Nagasaki print (*Nagasaki hanga*).

Though the origins may be traceable to the mid-seventeenth century, the height of the development and popularization of these prints was not reached until the early nineteenth century. By that time, according to present-day consensus, the Edo *ukiyo-e* tradition had reached a stage of overripeness. Though the Nagasaki print differs greatly from the *ukiyo-e* of Edo, dealing with a society from which the Edo prints were rigorously excluded, the great success of the *ukiyo-e* prints must have stimulated the development and popularity of the Nagasaki type. The attention of the Nagasaki genre was riveted on European civilization, and the people depicted had to be foreigners. Even the Japanese women who appear in the prints are represented as stand-ins for European women. (The Dutch were not allowed to bring European women into Japan, but Japanese consorts were provided by the authorities.) Outlandish birds and animals were sometimes added, but Japan as such was not shown, except for the specialized *Naga-saki-zu* ("Nagasaki pictures"). If the ideal of feminine beauty in the *ukiyo* print was

9–10. *A Depiction of All the Peoples of the World* (left) and *A Map of All the Nations of the World* (right). Block prints with tempera colors added. Each h. 136, w. 59.3 cm. 1645. Kobe City Museum of Namban Art. Linear elements were block printed and colors in tempera were added; thus these can be regarded as the earliest extant examples of Nagasaki woodblock prints. On the left, couples representing the "forty-two nations of the world" are headed by the Japanese warrior and his lady in the upper right-hand corner. The map of the world is actually a later reproduction, there being no extant copies of the original.

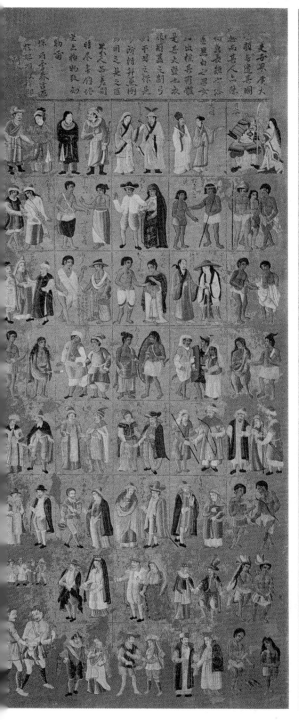
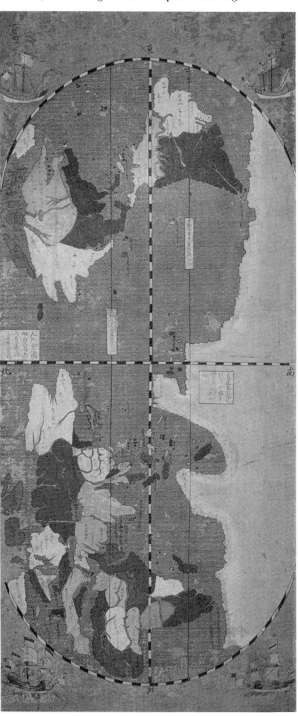

a woman "narrow of eye, with a high nose and a pink complexion, and hair as black as a wet crow's feather," the Nagasaki print sought vitality and individuality of countenance, and showed people dressed in everyday clothes. The style was a mixture of traditional Japanese *yamato-e* painting, Chinese painting, and European influences, and one might encounter inscriptions in Chinese, Dutch, or the native *kana* script. For all the admitted vulgarities that were occasioned by this mixture, there was also a cosmopolitan fascination, an interest in line, and a warmth of color that resulted in true elegance.

THE PUBLISHERS

The publishing houses of these Nagasaki prints did not last for many generations. Like their counterparts in Edo, they would prosper and then decline, but there was always a new publisher waiting to make a start. Among these publishers were the Hari-ya of Sakuramachi, which is thought to have flourished in the 1750s, followed by the Toshima-ya and its successor the Tomishima-ya, then the Bunkindō—the last three located in Katsuyamamachi. In the early nineteenth century we encounter the Yamato-ya of Imakajiyamachi, the Matsunaga of Hongemachi, the Gyūshin-ya and Baikōdō of Funadaikumachi, the Bunshōdō of Katsuyamamachi, and the Ringedō of Motoishibaimachi. Of these, the products of the Bunkindō and the Yamato-ya are the most plentifully in evidence.

The Hari-ya, which is thought to have begun publishing prints in the 1740s, was run by Hariya Yobee, who died in 1754, evidently with no one to succeed him. The surviving prints with his publisher's imprint are only three in number, but the subjects they depict—Dutchmen (pl. 11), Chinese, and Chinese ships—seem to have set the direction for future Nagasaki prints.

The most prosperous of the publishers were the Toshima-ya, the Bunkindō, and the Yamato-ya. In 1783 the geographer Kogawa Koshōken mentioned, in his memoirs of a trip to Kyushu, the Toshima-ya of Katsuyamamachi and its prints depicting Nagasaki with its Dutch and Chinese residents. The eminent student of European civilization Shiba Kōkan, visiting Nagasaki in 1788, also made a point of mentioning the publishers of Kachiyamamachi in his journal.

In 1750 Ōhata Bunjiemon of the Toshima-ya first came out with prints of ships and harbors. Among the variety of prints brought to Japan by the seagoing Dutchmen must certainly have been a goodly number depicting ships of their own nation coursing the seven seas. A maritime people like the Japanese, who were now absolutely excluded from the high seas, must have felt a certain longing and fascination when standing in front of such foreign pictures as the 1725 copperplate depicting a Greenlander in Rotterdam harbor (pl. 14) and the seventeenth-century engraving of a Dutch ship (pl. 15), both now in the Ijinkan in Nagasaki, as well as the tinted etching presumably of ships entering and leaving Amsterdam (pl. 12), a portion of which

was studiously copied by Aōdō Denzen, a Japanese specialist in Western-style print-making (pl. 13).

Nagasaki Pictures

The so-called Nagasaki pictures *(Nagasaki-zu)* that caught the eye of Kogawa Koshōken were also very much in fashion. The oldest of these were two panoramic prints by the artist Chikujuken that served as guides to the city of Nagasaki for visitors, who took them home as stylish souvenirs. A print published in 1764 bearing the seal of the founder of the Toshima-ya, Ōhata Bunjiemon, advertises its own utility and accuracy as a map with the following inscription: "Since the locations of the mansions of the various domains have shifted, and precincts have been changed in recent years, the new districts and the anchorages of Dutch and Chinese vessels have been carefully studied and precisely indicated on this block print." This sort of "Nagasaki picture" was such a useful guide that it was continued for many years with very little change in format (compare pls. 17 and 18), down to the fact that the name of Ōhata Bunjiemon continued to be used in later printings, even after his death. The influence of this type of panorama print can be seen in the "Yokohama pictures" *(Yokohama-e)* of the mid-nineteenth century and in the bird's-eye perspectives of such pictures as *A Comprehensive View of Yokosuka* (pl. 19) that were still being published after the Meiji Restoration of 1868.

In time these panorama prints of Nagasaki were accompanied by views of the buildings occupied by the Dutch on Deshima and of the Chinese enclosure. A magistrate of the shogunal government placed the first order for such pictures with the official painter Watanabe Shūseki in 1699. Then the Toshima-ya began to produce detailed prints of scenes within the foreigners' quarters, which was off-limits to everyone without official permission. This publisher must have been granted special privileges for the production of these prints, which served not only as curiosities to be purchased by travelers but also as sources of information for government officials. Stylistically these prints undoubtedly derived something from the Soochow New Year's prints of Ch'ing-dynasty China (pl. 20), which were introduced following the repeal of the prohibition on importing Chinese prints and hanging scrolls in 1700.

Various Works of the Nagasaki Publishers

The first proprietor of the Toshima-ya publishing house, Ōhata Bunjiemon, began his activities a few years before the death of Hariya Yobee, the artist who may have done the print titled *Woman of Holland* (pl. 16). The second proprietor was his son Denkichi, who changed the name of the shop to Tomishima-ya in the 1780s. The third in line did not produce any notable prints and the fourth-generation successor entered the employ of a competitor, bringing the establishment to an end.

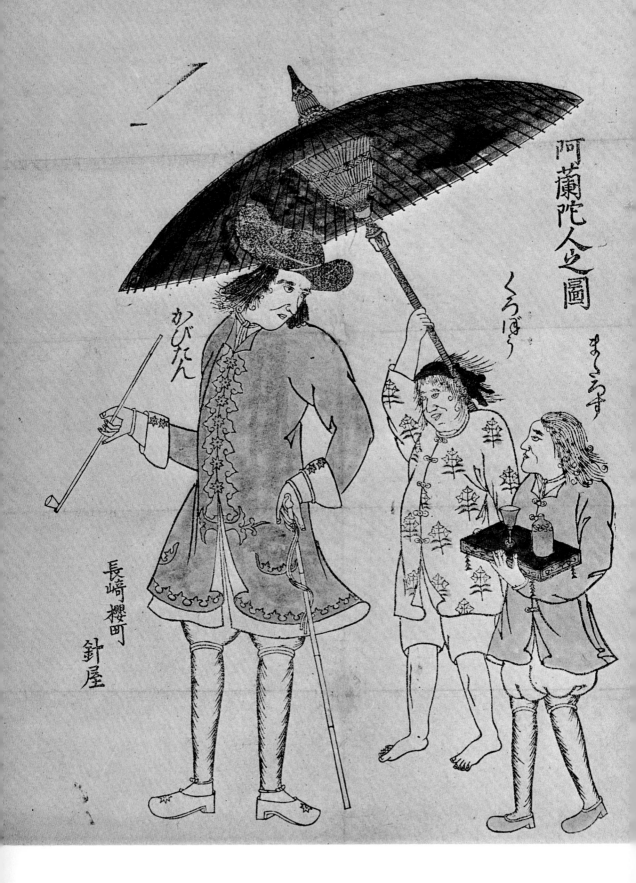

阿蘭陀人之圖

くろぼう

まるろす

かびたん

長崎櫻町

針屋

11. *Picture of a Dutchman.* Woodblock print with colors added. Published by Hari-ya. H. 42.8, w. 31.7 cm. 1750s. Kobe City Museum of Namban Art.

The caption reads "Picture of a Dutchman," and the publisher is identified as the Hari-ya of Sakuramachi in Nagasaki. The young man carrying the bottle and goblet is labeled "sailor," and the one holding the parasol "black boy," an indication that he is Javanese, and the swaggering Dutchman *kabitan* or "captain." The print, which was colored by hand, is thought to date from the early 1750s. The parallel line shading that can be seen in places shows the influence of copperplate engravings.

12. *Ships.* Dutch copperplate etching with colors added. H. 24.8, w. 36.2 cm. Late seventeenth or early eighteenth century. Private collection, Japan.

This tinted copperplate depicts merchant vessels entering and leaving what is probably the port of Amsterdam. Flying bunting and bulging sails depict the force of a stiff North sea breeze. The right-hand portion was used as a model for a study by Aōdō Denzen (pl. 13).

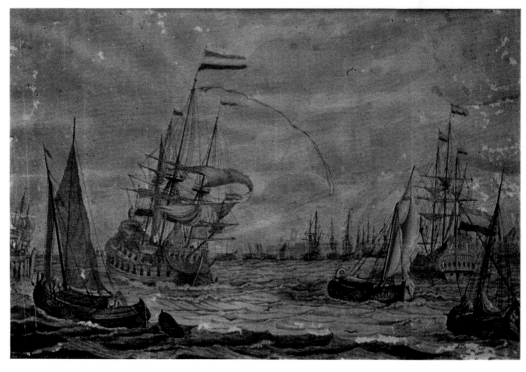

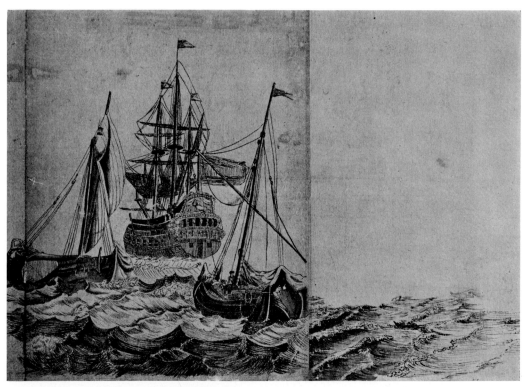

13. *Ships*, by Aōdō Denzen. Pen and ink drawing. H. 27.5, w. 37.7 cm. Based on a portion of the copperplate in plate 12. Private collection, Japan.

14. *A Greenlander and the Haven of Rotterdam.* Dutch copperplate engraving. 1725. Ijinkan, Nagasaki.

15. *Dutch Ship*. Copperplate engraving produced in Rotterdam. Seventeenth century. Ijinkan, Nagasaki.

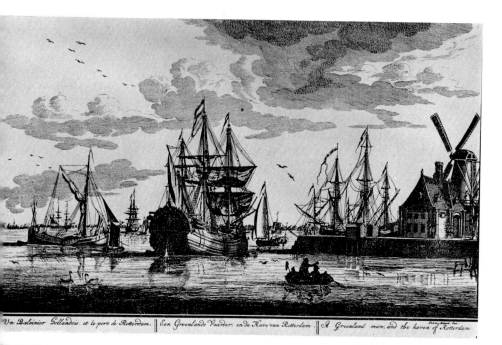

Un Baleinier Hollandois. et le port de Rotterdam. || *Een Groenlands Vaarder. en de Have van Rotterdam.* || *A Greenland man, and the haven of Rotterdam.*

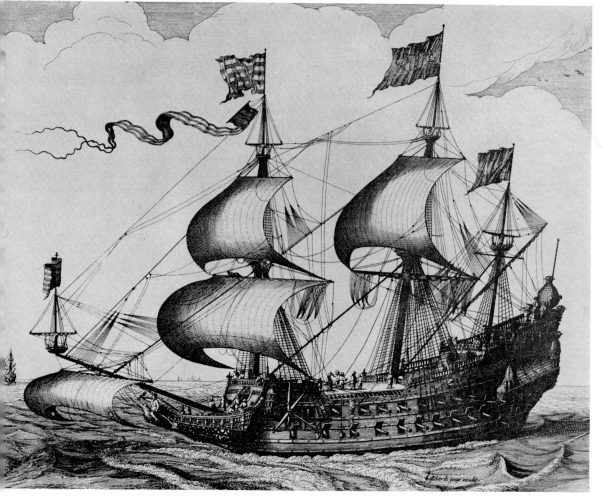

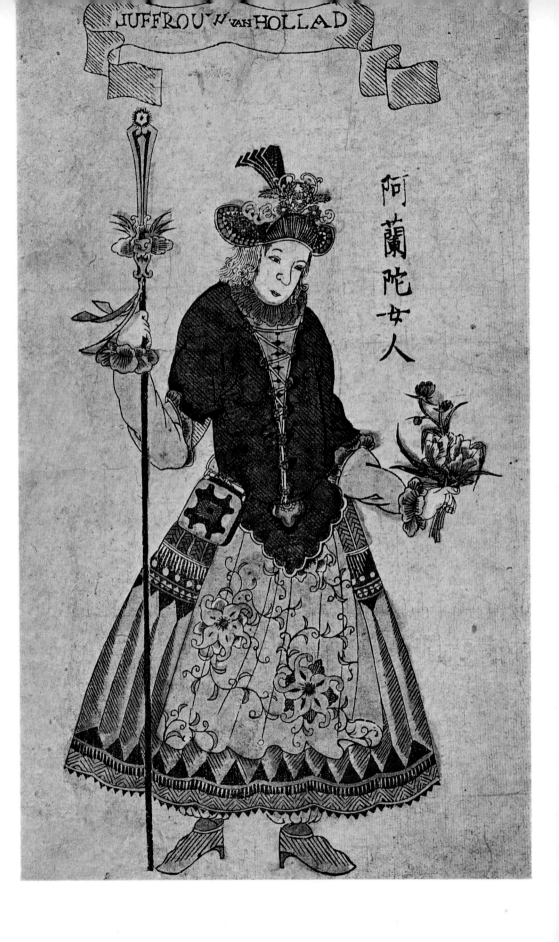

JUFFROUW VAN HOLLAD

阿蘭陀女人

16. *Woman of Holland*. Woodblock print with colors added. H. 42.3, w. 28.5 cm. C. 1760. Kobe City Museum of Namban Art.

This print bears the label "Woman of Holland" in Dutch and Japanese, and though it bears no publisher's mark, it is thought to be the work of the Toshima-ya and to date from around 1760. It appears to be a copy of an imported copperplate print, and the stylistic influence of the hatching commonly found in etchings and engravings is very evident.

41

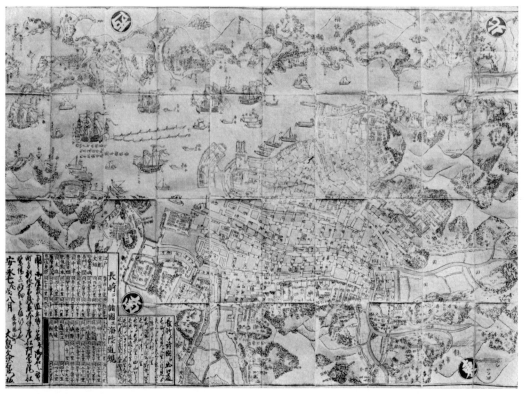

17. *Nagasaki*. Woodblock print. Published by
Toshima-ya. H. 67, w. 89 cm. 1778.

18. *Nagasaki*. Woodblock print. Published by
Gyūshin-ya. H. 110, w. 155 cm. 1802. Tokyo
National Museum.

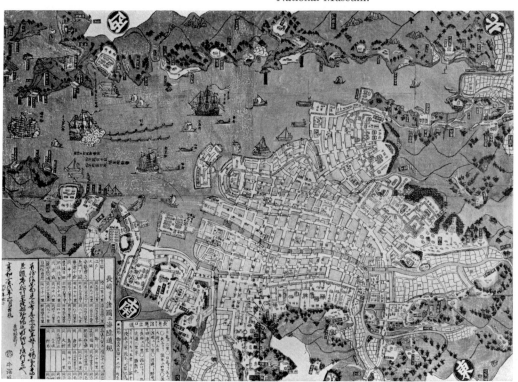

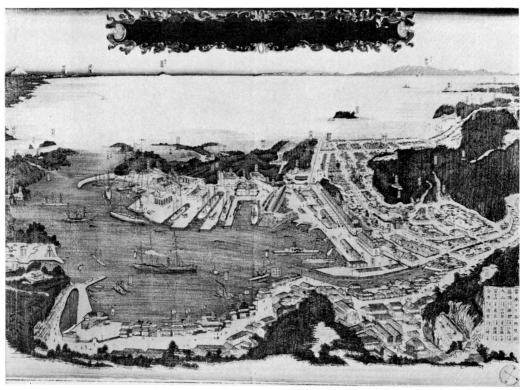

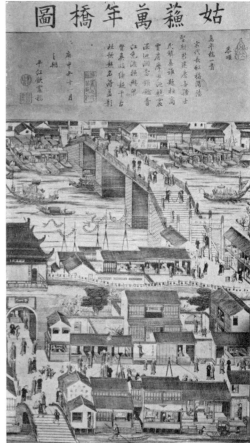

19. *A Comprehensive View of Yokosuka.* Woodblock
print. H. 33, w. 46.4 cm. 1877. Private collection,
Japan.

20. *The Ten-Thousand-Year Bridge in Soochow.*
Soochow New Year's print. H. 92.3, w. 53.3 cm.
1740. Kobe City Museum of Namban Art.

The new name had incorporated the word for wealth, and the shop produced printed representations of Dutch and Chinese ships laden with commerical wealth that were sold as popular good-luck charms. In addition to prints of Dutch and Chinese ships, the Tomishima-ya has bequeathed to us prints titled *Dutchman, Dutchman with a Black Boy from Batavia* (pl. 22), *A Procession of Korean Emissaries, Dutchmen Feasting and Drinking* from an original design attributed to the scholar Hayashi Shihei (pl. 21), and others whose subjects firmly established the direction for Nagasaki prints. Hayashi, who had made three visits to Nagasaki, published his *Kaikoku heidan* (Military Treatise on a Maritime Nation) at his own expense in 1791. According to the historian Charles Boxer, he paid for the venture by selling maps and prints of Dutch ships and other subjects that he had designed himself.

The first proprietor of the Bunkindō, who began publishing in the 1790s, is said to have belonged to a family that at one time had been retainers of the lords of Nagasaki. He used a seal that reads *Hokko*, was known as Matsuo Toshiemon, and died in 1809. The proprietor of the next generation was known as Shumpei, and his map of Kyushu is still extant (pl. 25).

As time passed, the Nagasaki prints came to be little more than a rewarming of old compositions. As representations of the customs and appearances of foreign peoples, they were basically naturalistic and representational in the European manner, even on occasion going so far as to reproduce the diagonal shading lines of a copperplate etching. Nevertheless, the style suffered from a certain naiveté and was not suited to the medium of woodblock printing, so the goal of producing truly illusionistic, Western-style prints remained elusive. Despite the exotic and unusual nature of the themes, the pictures could lapse into ornamentation and striving for effect. By the time of the later Yamato-ya prints an element of self-conscious picturesqueness had developed, but the Nagasaki print from its inception had aimed at representation and depiction rather than aesthetic expression. This becomes evident in the Bunkindō publications which followed those of the Toshima-ya. They depicted such novelties as camels, elephants, and ostriches (pl. 23), as well as Russians and their ships, which had just appeared in Nagasaki, though on other occasions the proprietor was not above reproducing Toshima-ya designs. Among the most remarkable Bunkindō productions were bird's-eye panoramas titled *View of Nagasaki Harbor* (pls. 26–27), which clearly demonstrated principles of linear perspective. Furthermore, as compared to the rather subdued Toshima-ya prints, the Bunkindō prints, generally speaking, showed forceful colors, applied by both block and stencil.

The Yamato-ya made its appearance in 1801. Its early prints tended toward intimate views rather than panoramas (see pl. 33 for an example of a close-up view of a Chinese junk), and representations of people were usually limited to one, or perhaps two or three people, with an emphasis on individual characterization. Of greatest interest are such prints as *Women of Holland* (pl. 24) and *Portrait of Russians on a State Occasion* (pl. 28), since their designs were commissioned from, or based on the work of,

the artist-in-residence on Deshima, Kawahara Keiga. The former print bears a striking resemblance to Keiga's *Captain from Holland* and *Mother and Child* in the collection of the Tokyo University Library. The latter bears the signature "Tojosky" (Toyosuke in Japanese), which Keiga had assumed as an artist name. It shows exceptional skill in capturing resemblances, demonstrates a clear application of Western chiaoscuro modeling, and approaches true character portrayal. The *Arrival of Vice Admiral Putiatin in Nagasaki* (pl. 34) also deals with the Russian penetration of Japan's seclusion.

Another artist figured significantly in the Yamato-ya productions: Edo-born Isono Bunsai, who, judging from temple death registers, must have come to Nagasaki around 1820 and married into the Yamato-ya family as an adopted son. One of the surviving prints bearing the "Bunsai" seal depicts Dutch ships and is remarkable for its accuracy and precision, even to the ship's longboat plying the calm waters of the harbor (pl. 32). Bunsai had trained under the early nineteenth-century *ukiyo-e* artist Keisai Eisen, and he brought the skills of a specialist to the Nagasaki print tradition with his precise representational depiction. However, at this point the Nagasaki prints were already influenced less by the Japanese woodblock print than by styles and media of prints of European origin. The Bunsai series *Eight Scenes from Nagasaki* (pls. 29–30) shows a tendency to merge the Nagasaki style with the landscape prints of the late *ukiyo-e* tradition. At this point the richly regionalistic tradition of the Nagasaki print had come to an end, but this survey may well conclude with an example of the rare products of the Matsunaga shop: *Picture of a Woman from Batavia* (pl. 31). Types of people were regarded with the same fascination that surrounded new imports from abroad, and it was this, really, that characterized the Nagasaki print from first to last.

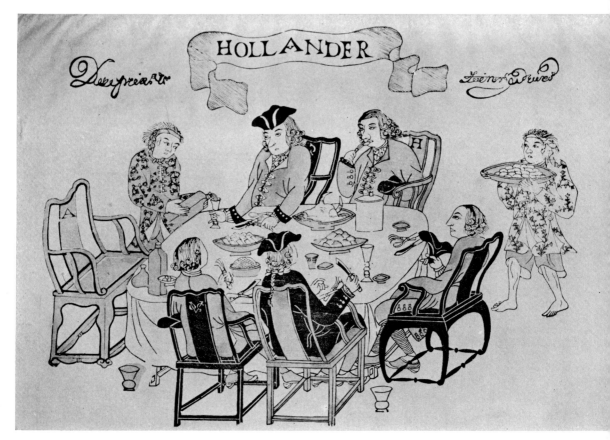

21. *Dutchmen Feasting and Drinking;* design attrib-
uted to Hayashi Shihei. Woodblock print. Pub-
lished by Tomishima-ya. H. 30.6, w. 42.7 cm.
Nagasaki Municipal Museum.

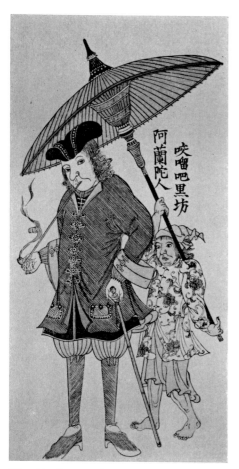

22. *Dutchman with a Black Boy from Batavia*. Woodblock print. Published by Tomishima-ya. H. 35, w. 21.5 cm. Nagasaki Municipal Museum.

23. *Ostrich (Fire-Eating Bird)*. Woodblock print. Published by Bunkindō. H. 31.4, w. 21.8 cm. Nagasaki Municipal Museum.

47

24. *Women of Holland.* Woodblock print. Published by Yamato-ya. H. 38, w. 26.4 cm. 1818. Kobe City Museum of Namban Art.

This color print was presumably issued by the Yamato-ya in 1818 when the wife of Jan Cock Blomhoff, commander of the Dutch post, arrived in Japan with her young son and a nurse. Her arrival was in violation of the prohibition against the entry of European women, and within two months of her arrival she was sent back to Holland, where she died without seeing her husband again. Her brief stay in Japan provided the occasion for family portraits painted by the Deshima painter-in-residence, Kawabara Keiga. These group portraits served as a basis for prints such as this one, which depicts Madam Blomhoff on the right and the nurse with the Blomhoff son on the left.

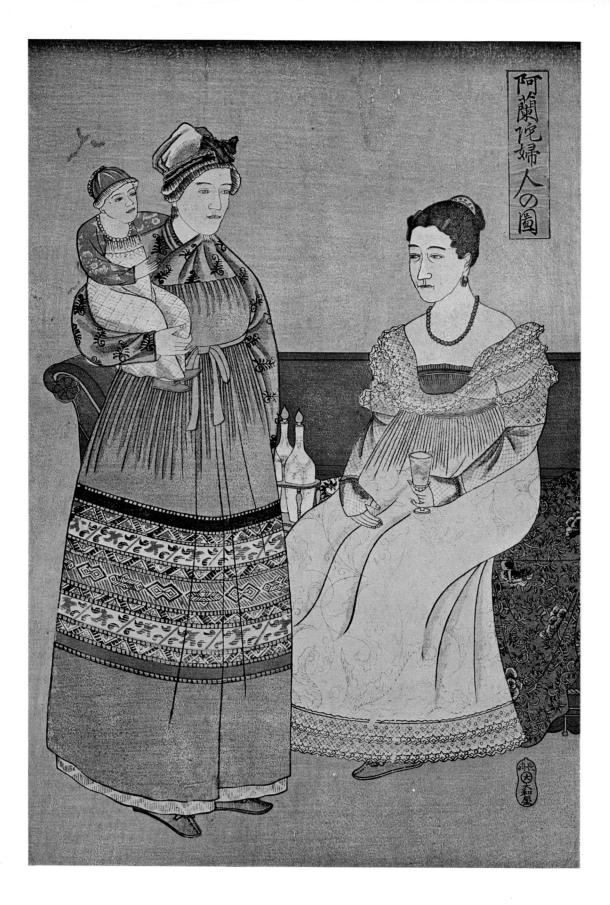

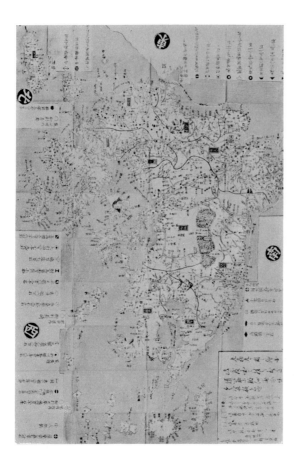

25. *Picture of Kyushu*. Woodblock print. Published by Bunkindō. 1813. Nagasaki Prefectural Library.

26. *View of Nagasaki Harbor*. Woodblock print. Published by Bunkindō. H. 21.3, w. 32 cm. Nagasaki Municipal Museum.

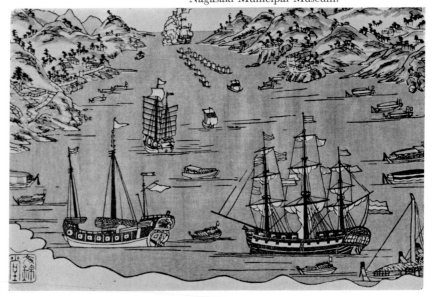

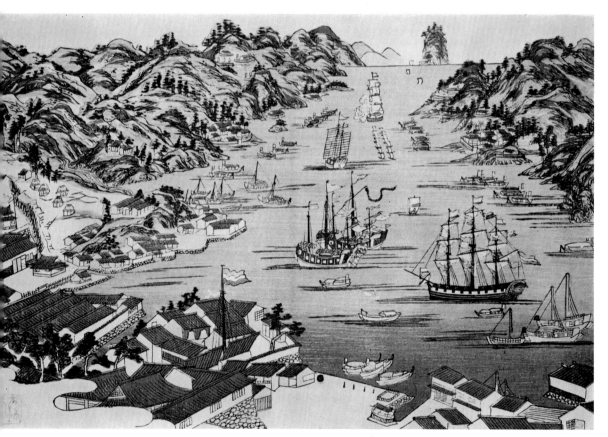

27. *View of Nagasaki Harbor*. Woodblock print.
Published by Bunkindō. H. 28, w. 39.5 cm.
Tokyo National Museum.

28. *Portrait of Russians on a State Occasion*. Wood-block print. Published by Yamato-ya. H. 38.8, w. 26 cm. Kobe City Museum of Namban Art. This is the last print of a set of seven on the subject of the arrival of the Russian vice admiral Putiatin in Nagasaki in 1853 with a request for the establishment of trade relations between Russia and Japan. This is one of the finest of the Yamato-ya prints, bearing the signature "Tojosky," a Dutch transliteration of "Toyo-suke," the artist name assumed by the designer Kawahara Keiga. This design shows Keiga's command of Western-style shading and the psychological perceptiveness of his portaiture.

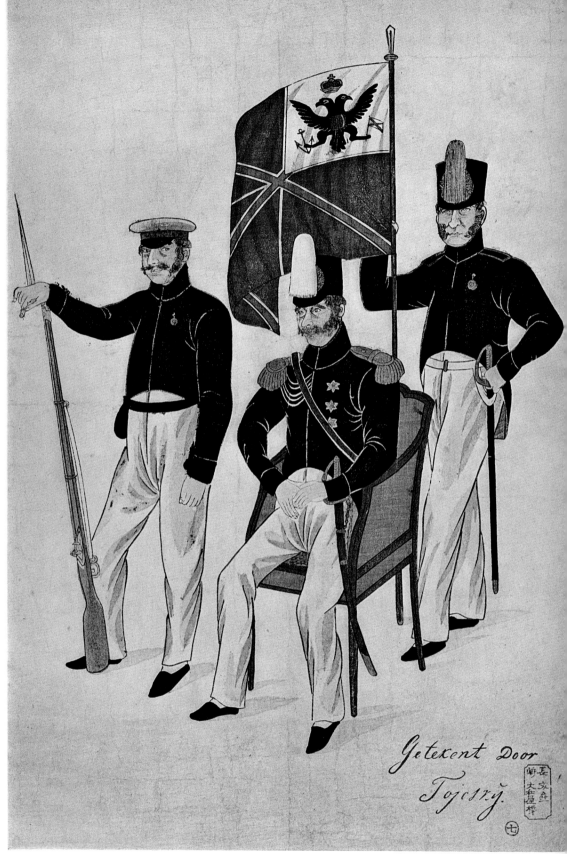

Getekent door
Tojosiŭ

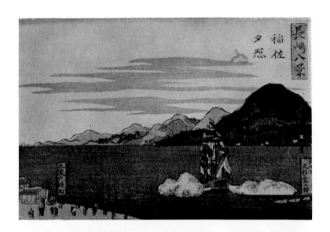

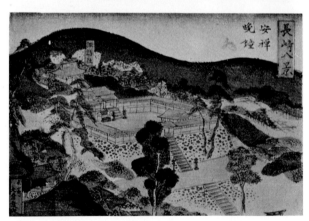

29–30. *Evening Glow* (above) and *Curfew Bells* (below). From the series *Eight Scenes from Nagasaki*, by Isono Bunsai. Woodblock prints. Each h. 13.6, w. 19.8 cm. Kobe City Museum of Namban Art.

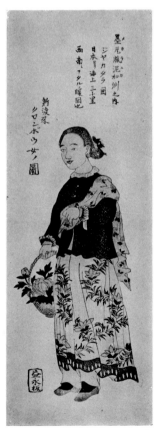

31. *Picture of a Woman from Batavia*. Woodblock print. Published by Masunaga. H. 45, w. 15.8 cm. Tokyo National Museum.

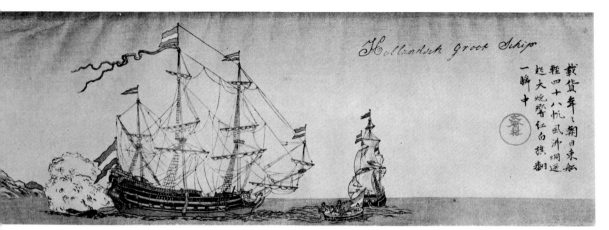

32. *Dutch Ships in Nagasaki*, by Isono Bunsai. Woodblock print. Published by Yamato-ya. H. 15.5, w. 40.3 cm. Nagasaki Municipal Museum.

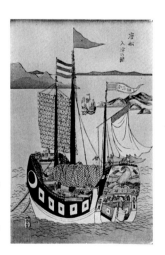

33. *Chinese Junk Entering the Harbor.* Woodblock print. Published by Yamato-ya. H. 35.6, w. 24 cm. Nagasaki Municipal Museum.

55

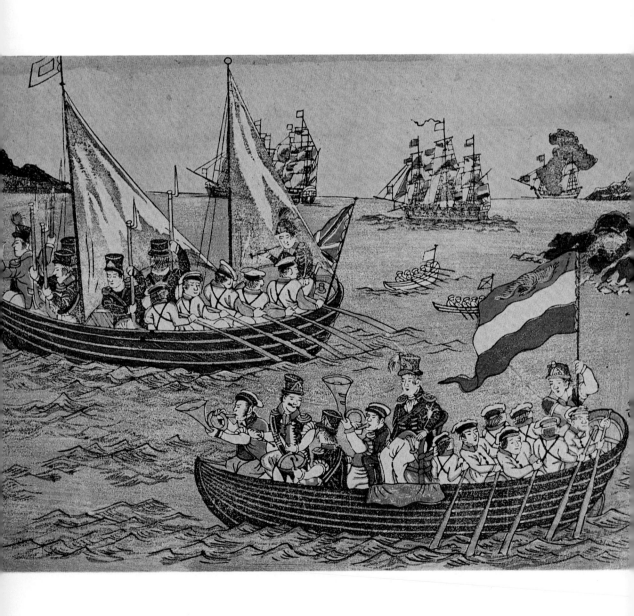

34. *Arrival of Vice Admiral Putiatin in Nagasaki.* Woodblock print. H. 32, w. 43.2 cm. Akita Prefectural Library.

This print depicts the arrival of Vice Admiral Putiatin in Nagasaki harbor. While his fleet remains anchored in the outer harbor, the admiral and a retinue of sailors in four longboats arrive amid the sounding of trumpets, the fluttering of ensigns, and the gleam of bayoneted firearms. This portentous intrusion of a substantial Russian naval force into Japanese waters, just after the first arrival in Japan of Commodore Perry of the United States, created much excitement in Nagasaki. The event was depicted in a wide variety of color prints.

5

HIRAGA GENNAI

Preeminent among scholars who brought the possibilities of "Dutch studies" to full realization was Hiraga Gennai (1729–79)—botanist, mineralogist, mining expert, potter, novelist, playwright, polemicist, and student of Western-style drawing and painting. Gennai was born into the lowest rank of the samurai class in the town of Shido in Sanuki Province (now Kagawa Prefecture). Through the good offices of the physician to Lord Matsudaira of the Takamatsu domain, the young Gennai was made responsible for the medicines of the daimyo's household. From here he began to make his own way in the world.

By the time he was thirty-two he had gained a sufficient reputation for his scholarly abilities to be given special orders by his lord to study in Nagasaki, and the following year he was transferred to Edo where he was formally apprenticed to the scholar Tamura Ransui in the technical study of industrial production. During this period he was able to get in touch with a Dutch tribute mission that had come to Edo, and he seized the opportunity to pump these visitors for information, amazing them by what he had already accomplished in the field of European learning.

But Gennai's ambition, coupled with his frustration over the restrictiveness of his hereditary fealty to the lord of Takamatsu, prompted him to request a severance of these obligations in 1761. Of this experience he later wrote an essay titled *Hōhiron* (Treatise on Free Farting) on becoming a *rōnin*, or stipendless, masterless samurai:

> The *rōnin*'s delights are his single box of noodles and his single pint of sake. Permanently bereft of material possessions, I am also spared the futility of servitude to a lord. . . . The rice grains of my stipend do not adhere to the soles of my feet, I go around to the places I like and avoid the places that displease me, and I have at least the advantage of possessing myself in freedom for the remainder of my years.

These words of Gennai's reflect the troubled mind of a free spirit living in an age of feudalism. By becoming a *rōnin* he had bought his autonomy, and he would later transgress the limits of Confucian propriety with a series of satirical literary broadsides

aimed at feudal institutions. He once again took up temporary residence in Nagasaki from 1768 to 1770.

In Nagasaki he met the Dutch-language specialist Yoshio Kōgyū and with him embarked on a translation of a botanical work by the Dutch naturalist Rembertus Dodoneus. Kōgyū was the sort of person who could simultaneously conduct research in the medical sciences and experiment with the techniques of oil painting. His activities are a measure of the progress made since the shogun Yoshimune first relaxed the ban on Western books in 1720.

During this stay in Nagasaki Gennai added other areas to his interest in Western learning. He made a medical device for the generation of electricity for therapeutic purposes, and his demonstrations of electrical phenomena so amazed people that they thought him a sorcerer. At this time he also studied mining technology, and in 1763 he took part in mining operations in the Kanto region. In 1771 he proposed developing Amakusa clay (from Amakusa Island off the coast of Kyushu) for use in export ceramics. In 1773 he was summoned to northern Honshu by the lord of Akita, Satake Shozan, in whose service he made important improvements in the operation of local copper mines.

Gennai and Satake Shozan

Gennai's sojourn in Akita has become famous not just for his contributions to the nation's mining industry but also for his instruction of the lord of the domain, Satake Shozan (1748–85), in the ways of Western art. Gennai had collaborated with the Chinese Nampin illustrator Sung Tzu-shih in the production of a famous work on mineralogy in 1763, and his teaching in Akita shows this influence. Although Gennai did not mention Western art extensively in his writings of this period, his student Shozan recorded Gennai's theories in his own treatise *Gato rikai* (On the Understanding of Painting and Drawing), published five years after Gennai's arrival in Akita:

> According to Gennai, the human body is a circle with the navel at the central axis. When the body develops in the womb, it is probably like a flower on a stalk. Furthermore, the human eye is a sphere. For this reason the world is measured and ordered by the divided circle of the eye's vision. This, in sum, is the basis for the principles of drawing.

These words summarize Gennai's principle of graphic representation. But the egalitarian Gennai was not to free himself from the consequences of living in a feudal society after all. Satake Shozan, the lord of Akita, and not Gennai, would in time be regarded as the founder of the tradition of Western-style painting in Japan.

Shozan has left to posterity three albums of drawings *(Shaseichō)*. One album contains essays, in Chinese and Japanese, titled *Gahō kōryō* (A Summary of the Principles of Drawing) and *Gato rikai* (On the Understanding of Painting and Drawing), the

59

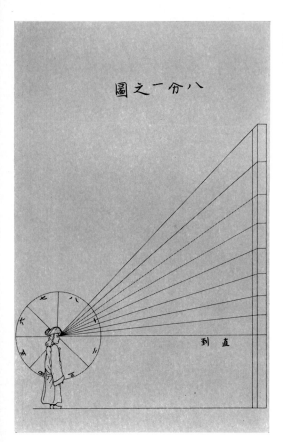

35. "The Eight-Sector Circle." Leaf from Satake Shozan's *Shaseichō* (Album of Representational Drawings). H. 34, w. 26.5 cm. 1878. Private collection, Japan.

36–37. "The Law of Perspective when Looking Down," "The Law of Perspective when Looking Up" (left); "Diagram of Viewing from Above," "Diagram of Viewing from Below" (right). Leafs from Satake Shozan's *Shaseichō* (Album of Representational Drawings). Each h. 34, w. 26.5 cm. 1878. Private collection, Japan.

latter of which has been quoted above. The first essay stresses the representational function of painting, while the second explains the principles through which representation is to be accomplished. The underlying principle is that one paints only what one can see, an attitude reminiscent of the nineteenth-century French realist Gustave Courbet.

As seen in the quotation appearing above, he also describes the limits of the eye's angle of vision by saying that it constitutes one-eighth of a circle, a sector that would encompass the angular distance from the horizon halfway to the zenith (pl. 35). He goes on to comment on the principles of shading and of image projection:

> When the sun is in the east, the shaded side is toward the west; and when the sun is in the west, the shaded side is toward the east. When an object is near water, the image is reflected upward. A painting should not be a decoration.

Concerning linear perspective he says:

> The eye sees near things as large and distant things as small. . . . When the distance becomes several leagues, the eyes fail and the object cannot be seen. This point of disappearance is at the horizon line, and the disappearing point is at the center of the sphere of vision, which becomes the basis for the picture [pls. 36–37].

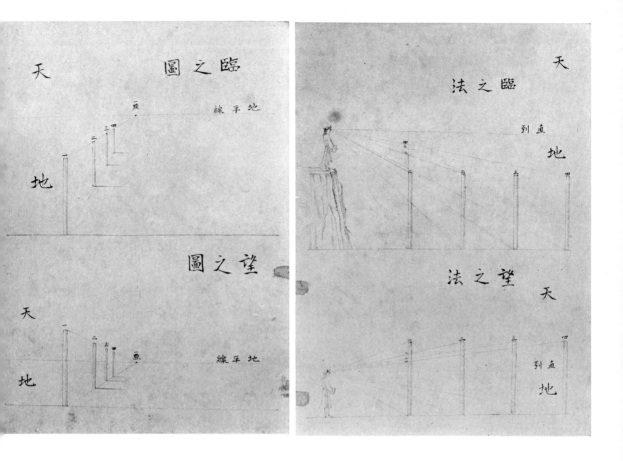

Describing the principles of atmospheric perspective he says:

> Trees that are near are a dense green and those that are far have only a thin coloration. This is not because the eyes lack the power to reach them but because the earth's atmosphere intervenes.

He concluded by saying that the person who would be a fashioner of pictures must master the natural laws of the heavens and the earth.

These words, which clearly suggest the attitudes of Hiraga Gennai, point to the historical direction from which Western styles were absorbed into the artistic tradition of Japan. Shozan's "Summary of the Principles of Drawing" contains a section on pigments that borrows from Gennai's 1763 encyclopedia of mineralogy. Shozan's publications incorporate, in fact, a collage of information garnered from such sources as the French academician Abraham Bosse's studies on the laws of perspective, which had been translated into Dutch in 1664 and thus became accessible to the Japanese. A study of the proportions of the human body (pl. 39) is derived from the *Groot Schilderboek* (Great Painter's Book) of the Amsterdam classicist painter and etcher Gerard de Lairesse (1641–1711). It was Gennai who had been the purveyor of all this data to the lord of Akita.

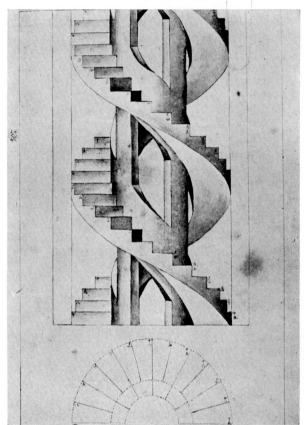

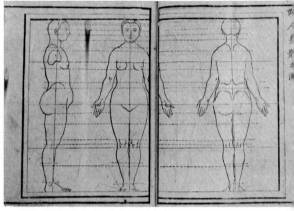

38. "Diagram of a Spiral Staircase." Un-published leaf from Satake Shozan's *Shaseichō* (Album of Representational Drawings). H. 34, w. 26.5 cm. 1878. Private collection, Japan.

39. "Diagram of the Human Body: Woman." Woodblock print. From Morishima Chūryō's *Kōmō zatsuwa* (A European Miscellany). Each h. 22.8, w. 16 cm. 1787. Kobe City Museum of Namban Art.

Shozan's theories were, of course, based on a theory of spatial representation that could not be found in traditional East Asian aesthetic theory. The traditional Chinese "rule of the six recessions" stated that the "recession of height" should be expressed in the dimension of up and down, the "planar recession" should be expressed in the horizontal dimension of right to left, and that the "recession of depth" should be expressed in the dimension of front and rear. To these were added the "recession of breadth," the "recession of illusion," and the "recession of haze." In East Asian pictures the point of view was always high above ground level. The upper elements were distant and the lower elements were near, and thus the term "up-and-down perspec-tive" was also used. In practical application these principles were normally blended harmoniously within a single composition. The point of observation was raised or lowered at will, and thus a highly subjective attitude toward painting as a spiritual emblem had been emphasized. The essays by Shozan described above brought to Oriental painting an epochal transformation in the representation of spatial relations. An illustration representing a spiral staircase that accompanied these writings splendidly details such complexities as foreshortening due to varying distances and varying degrees of inclination (pl. 38). Unfortunately, this picture was not published. In addi-

40–43. European copperplate engravings. From Satake Shozan's *Shaseichō* (Album of Representational Drawings). Each approx. h. 10.5, w. 20.5 cm. 1878. Private collection, Japan.

tion to the regular illustrations, the *Shaseichō* incorporated small imported copperplate engravings that were pasted in (pls. 40–43). Shozan's colleague, Odano Naotake, left among his prized possessions three more engravings that are thought to have been from the same series, plus an engraving by Georg Hertel based on a painting by F. X. Haberman (pl. 44). These rare imports were probably first acquired by Gennai in Nagasaki, and they testify to the extraordinary zeal for the study of European art that resulted from his visit to the Akita domain. The Hertel engraving, in particular, is thought to have influenced the style of Shozan's painting *Landscape with Lake and Mountains* (pl. 45). Although nothing can be said of the copperplate prints of Shozan or Odano Naotake since none have come down to us, these imports obviously influenced their paintings. Naotake, in turn, was to serve as an important guide to both Shiba Kōkan and Aōdō Denzen, whom we shall consider next.

Hiraga Gennai, who contributed so much to these radical new developments in Japanese art, succumbed to a mental illness and in 1779 murdered one of his students in the course of an argument. This great contributor to independence and progress died a miserable death in prison within the year.

44. Engraving by Georg Hertel based on a
painting by F. X. Haberman. H. 20, w. 30.5 cm.
Private collection, Japan.

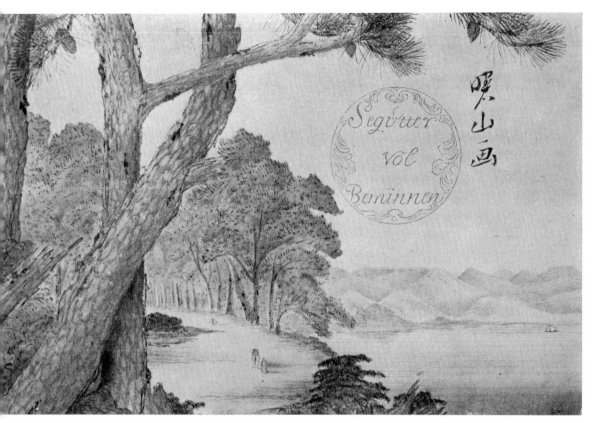

45. *Landscape with Lake and Mountains*, by Satake Shozan. Colors on paper. H. 16, w. 24.5 cm. Private collection, Japan.

6

SHIBA KŌKAN

THE ORIGIN OF COPPERPLATE PRINTING IN JAPAN

Another scholar who, like Hiraga Gennai, furthered the cause of the Japanese enlightenment with his studies of astronomy and painting was Shiba Kōkan (1747–1818). He was also the first Japanese to experiment with the production of copperplate etchings. Many historical uncertainties surround this man, extending even to the dates of his birth and death. Like Gennai he was an independent spirit who turned his back on the feudal conventions of his age, and his uninhibited penchant for drollery could lead the unwary reader to serious misunderstandings of things written by and about him. The following incident is recorded in the *Sekitei gadan* (Discourse on Art) by Takemoto Sekitei:

> Kōkan told how he once suffered an accident, and, setting up the false impression that he was already dead, he began lurking about a section of the Shiba district. A certain person, walking down the road, saw him from behind and pursued him, calling his name. Kōkan took to his heels and dashed off. The pursuer called out all the louder and drew close, chasing furiously. Kōkan turned his head, and with a pop-eyed expression screamed, "How can a dead man say anything!" And with this he dashed off without looking around again.

This episode, which has all the earmarks of a good story, certainly strains one's credulity, but a letter from Kōkan addressed to his close friend Yamakubi Shume, a samurai in the service of the lord of Nabeshima, dated 1815, seems to support the story:

> As I wrote in my last letter, I have set up a hermitage in the vicinity of the Azabu bluffs. I have hired an elderly housekeeper and live an easy life. . . . Last August I let it be known to the world that I had died, and no one came to visit. More recently it has become known bit by bit that I am not dead, and people have come around inquiring after me. By this process I have been resurrected and now I am once more consorting with talented men of the arts just as of old.

Kōkan's mention of his advertisement of his own death is a reference to a printed

statement titled *Shiba mugon jisei no go* (The Last Words of Shiba Kōkan), which bears a self-portrait. It reads:

> After Master Kōkan reached a state of senility, even though patrons of paintings persisted, he would not paint, and though all the lords issued him invitations, he would not enter their service. He grew weary of the construction of mysterious instruments for the study of the Dutchman's astronomy, and his only pleasure was in his retirement cottage. Last year he went to see the cherry blossoms of Yoshino, and after that he went to reside for a year at the Capital, returning this spring to Edo. Recently he became a disciple of a Zen master at Enkaku-ji in Kamakura, as a result of which he had a great enlightenment, then fell ill and died.
>
> For all living things, birth and death must be the same. We take shape for a brief period and then pass on into nothingness. There are those who for their virtue and excellence are remembered by later generations and who thus do not wither and disappear like ordinary creatures, but, even so, names do not last beyond a thousand years, while heaven and earth extend without beginning or end. Man is small but heaven is great. Ten thousand years are but a moment. How small we are! Alas!
>
> The eighth month of the tenth year of the Bunka period. 1813. Age seventy-five. The last words of Shiba Kōkan.

When we take this into account, the "How can a dead man say anything!" story cited above begins to seem like a true account. This man, so conscious of the judgment of posterity, was prompted on occasion to indulge his whims to excess, and therefore it should come as no real surprise that he falsified the "age of seventy-six" by an excess of nine years. The explanation of all this may lie in the external and internal changes that were indeed coming over him. It has even been speculated that Kōkan, as a critic of the feudal system, had reason to learn from the experiences of Hiraga Gennai, and may have set up this pose of madness as a self-protective smoke screen. Gennai had left to his pupil Odano Naotake a set of writings that incorporated warnings against antagonizing feudal authorities, enumerating the sorts of peccadilloes to be avoided, yet Naotake was also caught in the conflict between ancient feudal loyalties and libertarian philosophies. Kōkan's sudden withdrawal from life, and his losing himself in Zen meditation and seclusion, were undoubtedly symptoms of the same sort of mental anguish. In the concluding passages of a journal he wrote in 1811, he said:

> I covet fame and accomplishment, and this keeps me running. I have pursued accomplishment and fame for many years. . . . Is it not idiotic! Heaven and earth are infinite. Though fame may last a thousand years, it cannot last for a hundred thousand. When we think about this we should realize that fame endures only for our own lifetime. Everyone understands this.

46. *Vulture Peak*, by Shiba Kōkan. Woodblock print. H. 80, w. 28 cm. 1808. Private collection, Japan.

Kōkan did have reason to know about the vastness of space through his study of astronomy. Compared to the heavens, man must have seemed like particles of dust clinging to the earth. The foolishness of the pursuit of fame must have oppressed his spirit with a vast emptiness.

The date from which he began to add nine years to his age is thought to have been 1808. There is a white-on-black woodcut titled *Vulture Peak* (the Indian mountain near Bodhgayā where the Buddha Śākyamuni is said to have revealed the truth of the *Lotus Sutra*); the print bears his name, the date 1808, and gives his age as seventy-one (pl. 46). Presumably at the same time he also published a book on the subject of Vulture Peak, the illustrations for which were replicas of earlier work done by Kōkan for the *Kōmō zatsuwa* (A European Miscellany), a book written by Morishima Chūryō on European customs and published in 1787. These drawings of the mountain (pl. 47) were based on a copperplate illustration that had appeared in a book on India by François Valentyn, published in Amsterdam in 1726.

In 1808 Kōkan also published his *Kopperu temmon zukai* (Illustrated Explanation of the Astronomy of Copernicus), in which he set forth the revolutionary heliocentric theory of the solar system, and he produced, at the same time, an oil painting intended to illustrate the theory in a less technical fashion. The prohibition on heterodox studies, which had been promulgated by the shogunal administrator Matsudaira Sadanobu in the reform movement of 1790, was intended to underwrite the neo-Confucian philosophy of Chu Hsi, but the underlying emphasis was to make the discovery of truth the prime obligation of any scholar. Knowledge was to be gained through the investigation of all things, and the procedures for this investigation—abstract thought tested by experience and the linking of scholarly theory with practice—seemed quite in keeping with the spirit of Western science. However, the policy included admonishments against eccentric behavior and empty speculation, and the heliocentric ideas of Copernicus must certainly have seemed radical and unwarranted. It was inevitable that Kōkan's heterodoxy should be noted by the shogunal government. The official astronomer Shibukawa Bunzō recommended that the government take action to control the upsetting influences of these exotic doctrines, and indeed they were not set forth in writing again for another thirty-one years.

Let us examine the background of this maverick student of European learning, to the extent that the uncertainties of history will permit. From his own account his ancestors were from the Kii Peninsula on the Pacific Ocean, and this, he said, was the origin of his one-time pseudonym "Boundless Kōkan." He probably took the surname "Shiba" from the district of Edo where he was born, and he is thought to have studied under a master of the Kanō school of painters, Yoshinobu. In view of Kōkan's iconoclastic temperament, his experience with the formalism and traditionalism of the officially supported Kanō school must have proved a confrontation of opposite spirits.

He came to know Hiraga Gennai through the publication of Gennai's encyclo-

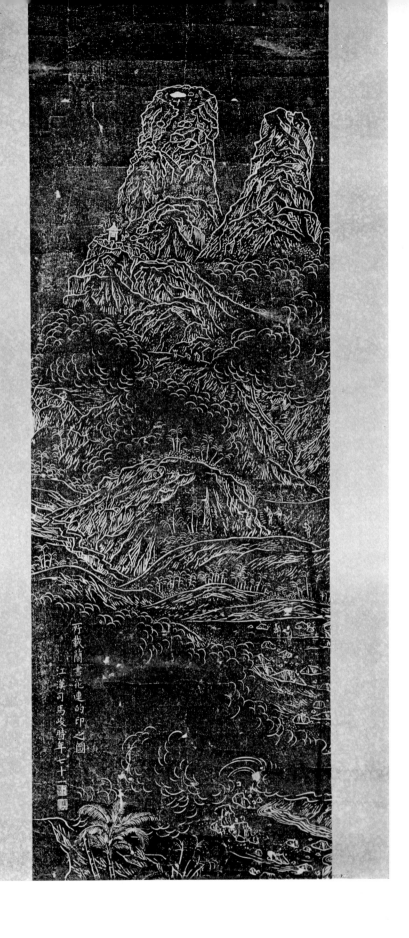

万载阑书化连的印之圖

江漢司馬受當年七十一

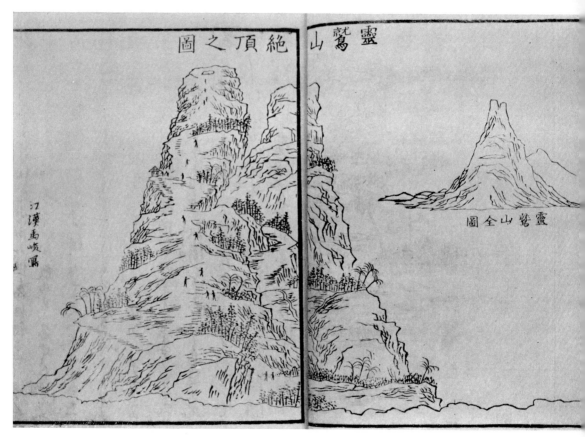

47. "Vulture Peak," by Shiba Kōkan. Woodblock print. From Morishima Chūryō's *Kōmō zatsuwa* (A European Miscellany). Each page 22.8, w. 16 cm. 1787. Based on a copperplate print that appeared in a book published in Amsterdam in 1726. Kobe City Museum of Namban Art.

pedia of mineralogy with illustrations by the Chinese artist Sung Tzu-shih. He also notes, in one of his memoirs, that he studied informally under the *ukiyo-e* painter and print designer Suzuki Harunobu (1725–70), who, around 1768 and 1769, was reaching the peak of his fame. After the death of Harunobu, Kōkan took the artist name of Harushige and designed a number of prints of beautiful women in the style of Harunobu. He also admits to faking Harunobu's signature on a number of designs. It seems that the faking of Harunobu was no problem as long as the woodblock carvers who had produced Harunobu's prints were still available to him, but the Western-style linear perspective to be found in these prints gives them away as the work of Kōkan. This is clearly evident in such works as *Enjoying Cool Air on a Veranda Platform* (pl. 48) and *Beautiful Woman on a Second-Story Balcony* (pl. 49), whose emphatic linear elements do not harmonize with the sinuous curves of the figures. Judged by the standards of the *ukiyo-e* "beautiful woman" genre, these can be regarded as only a poor reflection of the Harunobu tradition. In his *Kōkai ki* (Confessions) Kōkan says that he began to sign his prints "Harushige" because people failed to detect the forgery when he signed them Harunobu. Be that as it may, he did not persist in such endeavors and soon his attention was diverted more and more to painting in the Western style.

In 1781 he was called to join the household of the lord of Date in Shiba, where he

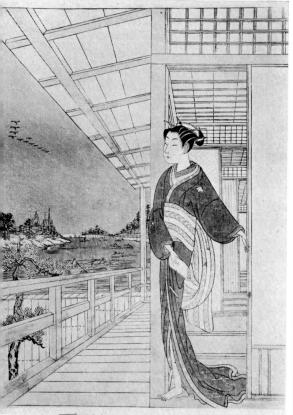

48. *Enjoying Cool Air on a Veranda Platform*, by Shiba Kōkan. Bearing the forged signature of Harunobu. Woodblock print. H. 27, w. 20.5 cm. Tokyo National Museum.

49. *Beautiful Woman on a Second-Story Balcony*, by Shiba Kōkan. Bearing the forged signature of Harunobu. Woodblock print. H. 28, w. 21.3 cm. Tokyo National Museum.

tried his hand at the impromptu or *sekiga* style of Japanese painting that was popular in Edo at the time, in which a painter produced a quick drawing upon command as a means of entertaining guests. He seems to have excelled in erotica done in the *ukiyo-e* style. It was also at this time that he joined a group of students of Western learning, headed by the scholar Maeno Ryōtaku, and it was through the linguistic assistance of the "Dutch studies" specialist Ōtsuki Gentaku that he discovered an article on copperplate etching in the Dutch translation of Noël Chomel's sixteen-volume encyclopedia (original French ed. 1709; Dutch trans. 1743, 1778).[1] As recounted in Kōkan's *Seiyōga dan* (Dissertation on Western Painting) published in 1799, he at last succeeded in mastering the techniques of copperplate etching after much trial and error:

> In a Dutch book by a certain person named Boisu[2] there is a description of the technique for making copperplates. I translated this with the help of Ōtsuki Gentaku, and in 1783 I finally worked out the process for the first time in Japan. In those other countries the people who employ these techniques have a different feeling from people in Asia. We cannot achieve their subtleties. My own talents are poor, and though I am only fifty, my energy is gradually declining. With these handicaps I shall demonstrate these new techniques from Holland as an offering to those who would take pleasure in them.

71

TECHNIQUES AND CREATIONS

The translations attempted by Ōtsuki Gentaku must have been fraught with difficulties, judging from the ambiguity of the translations of technical instructions on copper-plate etching that were to appear in print decades later, and one can imagine the difficulties that Kōkan must have encountered.

In 1783 Kōkan produced an etching of the view from the Mimeguri Shrine on Mukōjima in Edo (pl. 50), and despite some distracting crudities, this picture does indeed support his claim to be the originator of etchings in Japan. The following year he began his series of famous places around Edo that included *Papa's Tea Shop in Hiroo* (pl. 51), *View of Ochanomizu* (pl. 53), *Shinobazu Lake* (pl. 52), and in 1787 *View of Mount Tsukuba from Mimeguri Shrine* (pl. 55), *Ryōgoku Bridge* (pl. 54), and *Cool of Evening at Nakasu* (pl. 56). During this period he also used European-made view-box prints of famous scenes as models for such etchings as his *Serpentine in Hyde Park* (pl. 57) and *View of a Sanatorium* (pl. 58).

He was also involved, at this time, with depictions of European laborers and craftsmen. In these pictures the horizon line seems to move progressively lower, suggesting that, through the assistance of Hiraga Gennai, he had encountered Gerard de Lairesse's *Groot Schilderboek* (Great Painter's Book; pls. 61–65) and that he was familiar with the 1660 Dutch translation of the work on zoology by the naturalist John Johnston. Kōkan's painting employs the same principles of perspective and shading that are illustrated in these works. Furthermore, he traveled to Nagasaki in 1788 and had a chance to expand and develop these ideas through what he saw and heard there.

He described this Nagasaki sojourn in detail in his *Saiyū nikki* (Journal of a Visit to the West; see pls. 66–67 for examples of manuscript text and illustrations). According to an affidavit filed in the Iwakuni magistrate's office, the object of this journey was to advance his training as a painter, and it was a leisurely and circuitous route he pursued. On his outbound journey he left the coastal highway after passing Mount Fuji and followed the road up Mount Akiba, and when he reached Yokkaichi near Nagoya he took a side trip in the direction of Ise, where he met the priestly painter Gessen, who had studied under Maruyama Ōkyo.

He left Edo in late spring and arrived over six months later in Nagasaki, where he met the magistrate's official supervisor of Chinese-style paintings, Araki Gen'yū (1732–99). His comments on Gen'yū's ability as a painter are quite scathing. Gen'yū was sixteen years his senior, but the Edo-born Kōkan was thoroughly condescending in his attitude. During his one-month stay it was not painting alone so much as all things pertaining to Holland that absorbed his attention, and he was a regular visitor at the "Dutch studies" conferences of the physician and Dutch-language specialist Yoshio Kōsaku. Kōkan was also able to visit the Dutch colony on Deshima and to board a Dutch ship in the harbor. He even got over to the island of Hirado, the original Dutch station, and searched through the special collection of Dutch books belonging to

the scholar Matsuura Seigan. From Hirado he went on to visit the island of Ikitsuki, which was known for harboring secret Christians. In his handscroll, titled *Scenes of Whaling*, he incorporates a panel depicting his passage to Ikitsuki Island and including an inscription in which he describes how rough the trip was (pl. 68).

By late spring of 1789 Kōkan's *Wanderjahr* was over and he was back in Edo. Two years later the shogunal government issued its edict reinforcing the prohibition on the entry of foreign ships into Japanese waters, and in this defensive atmosphere Kōkan decided to begin the publication of a series of illustrated geographies. In a treatise on astronomy published in 1796 he bewails the inadequacy of Japanese navigation, saying, "Since those who sail Japanese ships go about without any knowledge of the heavens or the earth, in not a few instances they wreck their ships and lose their treasures at the bottom of the sea."

Along with this pursuit of scientific enlightenment Kōkan kept up his practice of painting. He devoted considerable attention to oil painting, producing works with titles like *Landscape with Foreign People*, *A Scholarly Dispute*, and *The Seven-League Beach at Kamakura*, all of which are thought to date from after his sojourn in Nagasaki. Tinted copperplates such as his *View of Mount Fuji from Yabe in Suruga Province* (pl. 59) and *Waka-no-ura on the Kii Peninsula* (pl. 60) are thought to date from after his return from Nagasaki.

After a while he discontinued altogether this publication of hand-tinted etchings and engraving. Among the possible reasons for this was the fact that Kōkan's public image suffered adversely after the sudden fall from high office of Tanuma Okitsugu, with whom he was associated via his friend Hiraga Gennai. In 1787 Matsudaira Sadanobu became the leading senior councilor and began the Kansei Reform, named for the current era of the Japanese calendar. Sadanobu pressed his anti-Tanuma policies even to the point of revoking Tanuma's programs for increasing national productivity. Among the trends that pushed Kōkan from a position of prominence were the official declaration of the orthodoxy of neo-Confucianism, the prohibition of heterodox teachings, the arrests of secret Christians, the punishment of the satirist and *ukiyo-e* artist Santō Kyōden and his publisher Tsutaya Jūsaburō. Moreover, in 1794 Sadanobu established a special relationship with the engraver Aōdō Denzen. Denzen seems to have taken full advantage of his situation and the progress he had been making in learning the techniques of etching. Furthermore, on a purely practical level, Kōkan may have had more and more difficulty in getting nitric acid or in producing an etching mordant of his own concoction, for his design of *Vulture Peak* of 1808 (pl. 46) and the illustrations for the publications dating from his last years were all intended for traditional woodblock printing. A journal of his trip to Nagasaki published in 1794 originally contained critical remarks about Japan's international position, but these comments were excised from the printing blocks before publication. Whatever problems he may have suffered from official sanctions, the essays written in connection with his trip

73

to Nagasaki continued to be published, and in 1815 an expanded journal of his trip to the west came out in an edition whose text was a facsimile of his own calligraphy.

In 1799 Kōkan produced his famous *Seiyōga dan* (Dissertation on Western Painting). In this he explained his "three-facet principle":

> One facet of an object will be bright because it is illuminated directly by the sun's rays, the second paler because it is illuminated obliquely by the sun's rays, and the third facet dense in color because it is shaded from the sun's rays and is in the dark. In order to engrave these variations in shading one makes parallel lines. Where there is one layer of lines the shading is light, but where a second layer is superimposed, the shading is dark.

In this passage Kōkan deals with the sense of the solidity of an object conveyed by the incidence of light. He has achieved a simple but fundamental interpretation of the representational realism that was in operation in Europe from the latter part of the Renaissance onward.

In 1805 Kōkan published a set of volumes titled *Oranda tsūhaku* (Importations from Holland), which included an illustration of the Colossus of Rhodes with a lamp in the palm of its right hand, and this design was later used as the basis for a rather grotesque broadsheet print by the *ukiyo-e* artist Utagawa Kunitora (pl. 69). In this same work Kōkan speaks of the practical and representational functions of etchings and engravings, and admits that the skill of foreign artisans cannot be duplicated, indicating that he was never satisfied with the quality of his own accomplishments. He may well have diverted his waning energies to writing and to discussing art and literature with his colleagues because he recognized his own limitations in Western printmaking.

The self-proclaimed "Boundless Kōkan" we encountered at the outset had been replaced by the figure of an old man, much reduced in estate. As late as 1808 and 1816, two years before his death, Kōkan was publishing works on astronomy, but he had ceased to be Kōkan the artist. Like Hiraga Gennai he was a positivist in pursuit of truth, and because he held to this persuasion he was swept aside by the currents of the feudal age in which he lived. Nevertheless, the copperplate print techniques he worked on without a full sense of accomplishment were brought to completion at the hands of a dyer from the northern province of Michinoku, Aōdō Denzen.

50. *View from Mimeguri Shrine,* by Shiba Kōkan.
Copperplate etching. H. 25, w. 38 cm. 1783. Kobe
City Museum of Namban Art.

51. *Papa's Tea Shop in Hiroo*, by Shiba Kōkan. Copperplate etching with colors added. H. 25.8, w. 37.7 cm. 1784. Homma Art Museum.
In this hand-tinted etching Kōkan strives to convey the vastness of land and sky. The cloud effects here are not etched, but achieved through the addition of colors. Hiroo is near the Azabu district of modern Tokyo.

52. *Shinobazu Lake*, by Shiba Kōkan. Copperplate etching with colors added. H. 25.8, w. 37.7 cm. Tokyo National Museum.
This famous lily pond with its temple to the Goddess Benten located at the center is still one of the chief attractions of Ueno Park in Tokyo. This print, a reverse image, was made to be seen through a viewing device with a mirror.

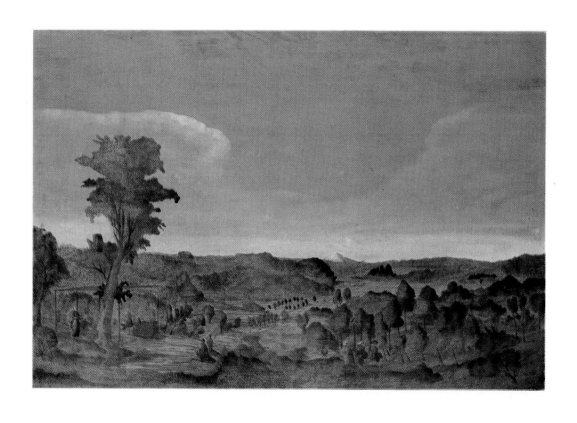

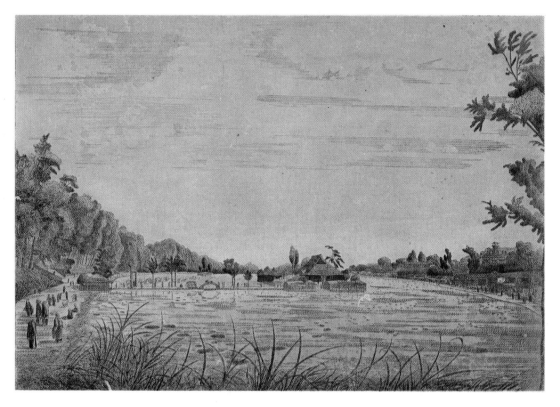

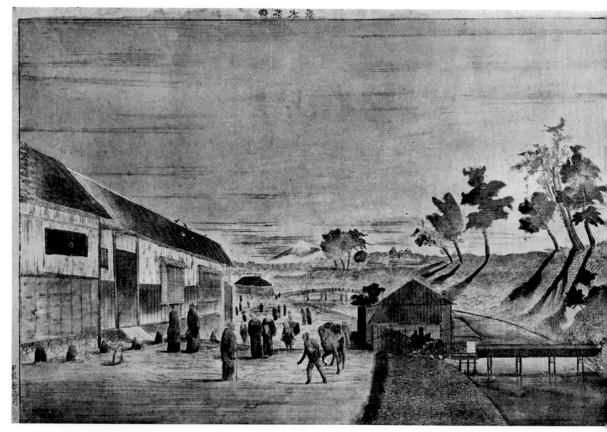

53. *View of Ochanomizu*, by Shiba Kōkan. Copperplate etching. H. 25.8, w. 37.7 cm. Homma Art Museum.

78

54. *Ryōgoku Bridge*, by Shiba Kōkan. Copper-
plate etching. H. 25, w. 38 cm. Private collection,
Japan.

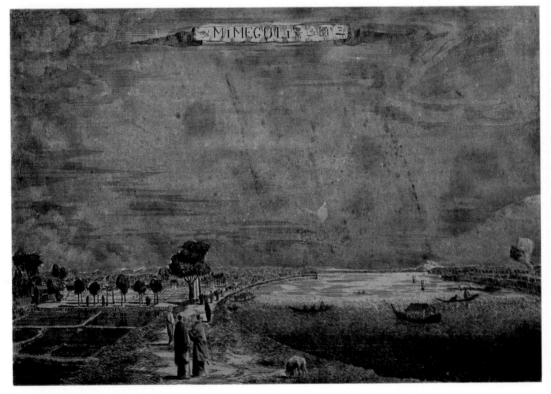

55. *View of Mount Tsukuba from Mimeguri Shrine*,
by Shiba Kōkan. Copperplate etching with
colors added. H. 25.8, w. 37.7 cm. Homma Art
Museum.

The Mimeguri Shrine was located in Mukō-
jima on the banks of the Sumida River, and
Mount Tsukuba is visible in the distance on the
far side of the river. The expanse of sky and the
low horizon shows the influence of Dutch land-
scape art.

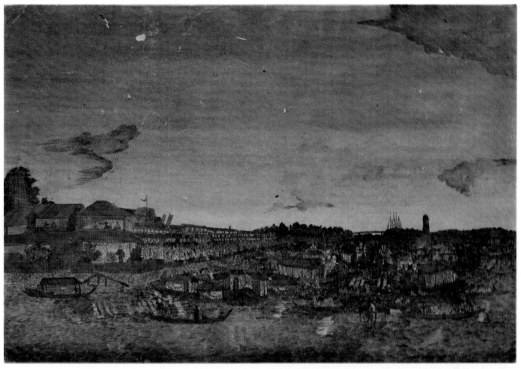

56. *Cool of Evening at Nakasu,* by Shiba Kōkan.
Copperplate etching. H. 25.8, w. 37.7 cm.
C. 1784. Homma Art Museum.

Enjoying the cool of evening on a lantern-lit
boat anchored in the Sumida River was a
popular pastime for the pleasure seekers of eight-
eenth-century Edo (modern Tokyo). The pic-
turesque atmosphere is enhanced by the clus-
tered masts of the distant fishing fleet, the
row of restaurants and tea shops lining the
riverbank, the darkening sky, and the glimmer
of the lanterns reflected in the rippling waters.

57. *The Serpentine in Hyde Park*, by Shiba Kōkan.
Copperplate etching. Reconstructed from im-
ported engravings. H. 25.8, w. 37.7 cm. Private
collection, Japan.

58. *View of a Sanatorium*, by Shiba Kōkan. Cop-
perplate etching. Re-created from an imported
print. H. 25.8, w. 37.7 cm. Private collection,
Japan.

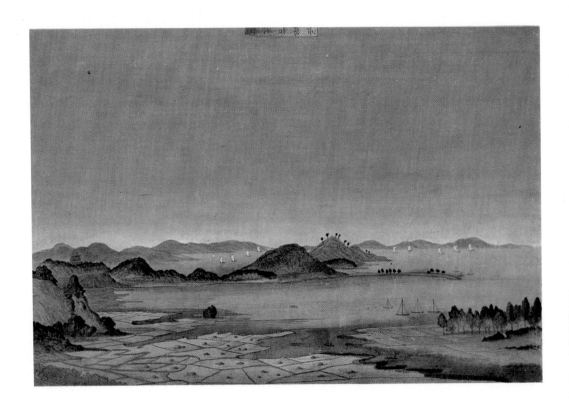

59. *View of Mount Fuji from Yabe in Suruga Province*, by Shiba Kōkan. Copperplate etching. H. 25.8, w. 37.7 cm. Homma Art Museum.
Mount Fuji is seen in the distance in this reverse-image view from Yabe, near Mount Kunō in what is now Shizuoka Prefecture. A depiction of this scene appears in the journal Kōkan kept of his visit to Nagasaki in 1799 (pl. 66); so this print is thought to date from after this trip. Reverse image prints were often made for use in viewing devices containing mirrors.

60. *Waka-no-ura on the Kii Peninsula*, by Shiba Kōkan. Copperplate etching with colors added. H. 25.8, w. 37.7 cm. Homma Art Museum.
It seems likely that Kōkan visited his ancestral home in the province of Kii (now Wakayama Prefecture) on his return from Nagasaki, and that this print is the result of his visit. As in the case of pl. 59, a mirror image of the actual scene is presented.

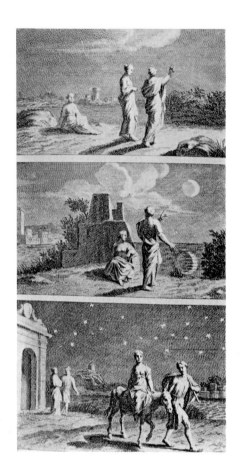

61–65. Perspective studies from Gerard de Lairesse's *Groot Schilderboek* (Great Painter's Book). 1707. Kobe City Museum of Namban Art.

66. A view of Mount Fuji from Yabe in Suruga Province. Two pages from Shiba Kōkan's *Saiyū nikki* (Journal of a Visit to the West). Ink on paper. 1815. Tokyo National Museum.

67. Sketch of a Dutchman. Two pages from Shiba Kōkan's *Saiyū nikki* (Journal of a Visit to the West). Ink on paper. 1815. Tokyo National Museum.

八部山ヨリ眺望ノ圖

昔雪舟延千支那而
所圖富嶽之景何
至望無知者余登
於駿陽矢部神
陀洛山上始觀之
寛政己酉春
三日三日寶珍
平者宿宿ノ入
大覧

江尻　清見寺山　清水　根箱　伊豆山巻　大峰山　夕暮　八部　観音山

者二人来ル門と入ホそ嫡ところ袂と
改ひ何殿ても持へべると禁て書く行と
去年白戸石可長崎だと云るく人ぶ宿
こて逗ぎる丸ん外料ストッツルと云者也
吾千満へ糸ぐる葉て白戸て約束すと云
ぬまみ吾と云て先正立て人と吾壽平
部屋れる行路く何やう语よ一向つ来
通只テイクまると云るとも見白戸れ
丸の山え何くと圖しても乃るめくと云るす
なくまよそごるれたコムカーモルく

蘭人　ストッツル
イキカーモル　コム々
我部金来々

九七

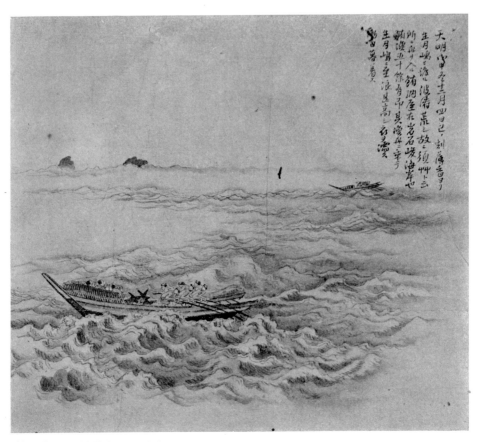

68. *Scenes of Whaling*, by Shiba Kōkan. Detail.
Handscroll. Ink and colors on paper. H. 27.7,
1. 389 cm. 1749. Private collection, Japan.

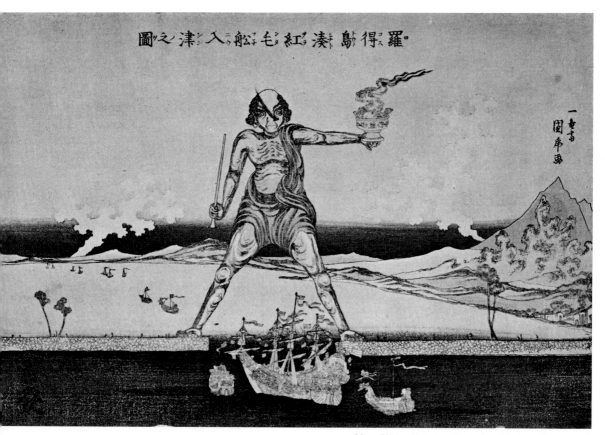

69. *Ships Entering Port beneath the Colossus of Rhodes*, by Utagawa Kunitora. Woodblock print. H. 26.5, w. 38 cm. Tokyo National Museum.

7

AŌDŌ DENZEN

THE IKOKU-YA AND THE ART OF DYEING

Aōdō Denzen (1748–1822), whose boyhood name was Zenkichi, was the second of three sons of an agricultural implement dealer. The father's name was Nagata Sōshirō, and his shop, located in Sukagawa in what is now Fukushima Prefecture, had been a family enterprise for five generations. It is recorded that prior to 1615, when they settled in Sukagawa, the Nagatas had been traveling distributors of Shintō ritual offertory materials from Ise Shrine and that they were based in Ise.

When Denzen was seven years old his father died and his elder brother Jōkichi succeeded to the family business. Jōkichi then abruptly decided to apprentice himself to a Kanō-school painting studio, and he took the artist name of Konzan. While developing as an amateur painter he departed from the family calling and set up an indigo dyeing establishment bearing the name Ikoku-ya. With the recommendation of the local daimyo, the lord of Shirakawa, Jōkichi was put to work on the restoration of the decor of the Tokugawa mausoleum at Nikko on the occasion of the visit of the shogun Ieharu in 1776, indicating that as a dyer, with training in painting as well, he had already gained recognition for his artistic capabilities in his own locality. Naturally Denzen received instruction in painting from Jōkichi. The two brothers united their efforts to promote the success of their new business, aided by the fact that Sukagawa was the mercantile center for the Shirakawa clan.

The meaning of the term *ikoku* (foreign-style) dyeing, which Jōkichi established in that locality, has been explained in various ways, but the contents of a pattern book titled *Kyōjirushi komonchō* (Kyoto-style Fine Patterns) and labeled "Ikoku-ya" (pls. 70–73) reveal that the technique used by the Ikoku-ya was based on that of the small-pattern stencil dyeing then popular throughout Japan and still practiced in the Shiroko and Jike districts of Suzuka City in Mie Prefecture (now designated an Important Intangible Cultural Property by the Japanese government). In general, the term "*ikoku* dyeing" denoted the small-figure print or calico imported from India, and that meaning undoubtedly lay behind the name "Ikoku-ya" that Jōkichi gave to his enterprise. It is thought that Denzen himself possibly created some of the patterns the shop produced for certain large-scale geometric patterns and a "hoe blade"

pattern of the Ikoku-ya are not to be found in the patterns from Jike and Shiroko.

In spite of these occupations Denzen's fascination with painting grew unabated. His intense absorption with painting was enough to attract the astonished attention of Matsudaira Sadanobu, who succeeded Tanuma Okitsugu as the shogun's chief policy maker and was also lord of the Shirakawa domain in which Denzen was born.

Sadanobu wrote in one of his memoirs that Denzen was so obsessed by painting that he would forget to eat and sleep, and thus neglected his official duties shamefully. Denzen was finally brought to task by Sadanobu in 1794. Sadanobu admonished him severely, but in the face of Denzen's total dedication to painting, Sadanobu finally relented and had him apprenticed to the eclectic *bunjin* or literati painter Tani Bunchō (1763–1840). It is said that by this time Denzen was already making woodblock and copperplate prints.

Sadanobu, who was a leading patron of the arts, had been observing Denzen's work with the closest scrutiny. He was born into the aristocratic Tayasu family and descended from the shogun Yoshimune. The Tayasus not only had Tani Bunchō under their aegis, but were also patrons of the monk Haku'un (1764–1825), who received his training at the temple Jūnen-ji in Sukagawa and was known as a traveling landscape painter. Denzen must have come under the monk's influence also.

The years that preceded his discovery by Sadanobu were eventful ones in Denzen's life. In 1785, when he was thirty-seven, he made a trip to Ise and paid a visit to the monk-painter Gessen (1741–1809), who was attached to the temple called Jakushō-ji in the Furuichi district.

Gessen had begun his religious training in Nagoya at the age of six and devoted himself to painting from childhood. While in Edo on temple business in 1758 he received technical instruction from the painter Sakurai Sankō, who worked in the tradition of Sesshū. In 1764, at the age of twenty-three, he went to Kyoto to begin a ten-year residence at the Chion-in. Through his studies under Maruyama Ōkyo, among others, he encountered and participated in the revolutionary new styles of painting that were coming into vogue. Gessen was highly praised by the contemporary literati-school artist Tanomura Chikuden, who compared him with Tani Bunchō and lauded his inventiveness and delicacy of line. The aptness of this appraisal is still evident in paintings that have been preserved at the Jakushō-ji, where Gessen served as abbot, and at the Ise Shrine Repository (pls. 74–76).

This was the Gessen with whom Denzen studied in Ise. Through Gessen he also learned of some of the noted artists of Gessen's acquaintance, including the lord of the Ise Nagashima Castle, Masuyama Sessai, who painted in the style of Maruyama Ōkyo and Ch'en Nan-p'in, and the Edo painter Haruki Nanko (1759–1839), who went in Sessai's service to Nagasaki. In 1788 Kōkan visited Gessen at Jakushō-ji, and Gessen expressed his eagerness to learn Western-style painting from Kōkan. The following

91

70–71. Front (left) and back (right) covers of *Kyōjirushi komon-chō* (Kyoto-style Fine Patterns). Published by the Ikoku-ya. Each h. 33, w. 21 cm. Takeuchi Collection, Fukushima Prefecture.

passage appears in the second volume of Kōkan's *Saiyū nikki* (Journal of a Visit to the West):

> Gessen talked along, and without supplying any fish he brought out sake, and finally, after 6 A.M., went to bed. The next day he had me show him some odds and ends of oil paintings, and the following morning we went sightseeing at Futami-ga-ura. He urged me to pay him another visit. When I made a rather precipitous departure, Gessen became extremely angry with me.

The following year, 1789, Gessen visited Sukagawa while traveling to collect funds for building a sutra storehouse, and while there he had the pleasure of reuniting with his protégé Denzen. The importance of this relationship is suggested by Gessen's influences on Denzen's developing style in figure painting, which fully assimilated Gessen's rather slender body form, prominent nose-bridge, and accented, single-brushstroke eyes, as seen in Denzen's unsigned painting of a musical ensemble (pls. 77–78) and his painting of a "nighthawk" or low-class prostitute (pls. 79–80). After Denzen came under the patronage of Matsudaira Sadanobu, however, he directed his efforts toward mastering Western techniques, in which his progress was very rapid.

92 The future course of Denzen's career was determined by the fateful meeting with

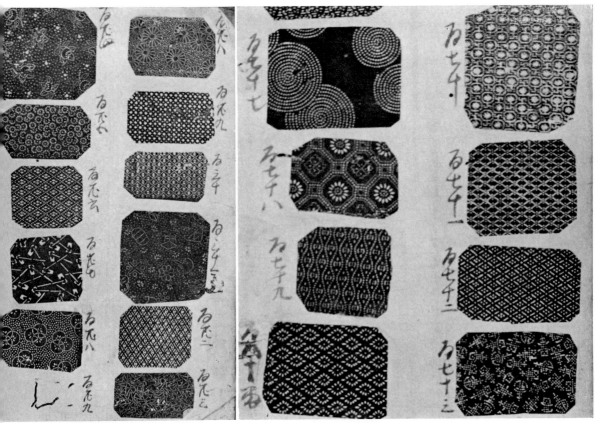

72–73. Pages from the *Kyōjirushi komonchō* (Kyoto-style Fine Patterns). Published by the Ikoku-ya. Takeuchi Collection, Fukushima Prefecture.

Sadanobu in 1794, whereupon he sold his dyeworks to a friend, moved to the vicinity of the Shirakawa Castle, and changed his name to Nakada. By 1796 he had secured a position in the domain that was the general equivalent of official court painter. He used two signature seals with the readings "Nakada Zenkichi" and "Michinoku Sukagawa" said to have been given to him by Sadanobu himself (pl. 81). It wasn't until 1805, after several other names had been tried, that he emerged at last as the copperplate engraver "Aōdō Denzen," an imposing name combining the words for Europe and Asia and which was apparently bestowed upon him by his lord, Sadanobu.

As mentioned above, his interest and experimentation in copperplate printmaking must have begun considerably earlier, as is evidenced by Sadanobu's own references to Denzen's woodcut and copperplate printmaking in a journal of 1797. In 1798 Sadanobu summoned Denzen to his Edo mansion, showed him a map of the world printed in Holland, and ordered him to master the theory and practice of copperplate printmaking. The map in question, which had already been copied by Shiba Kōkan, bore the date 1791, and had been brought back to Japan by the castaway fisherman Daikokuya Kōdayū, who had been rescued by Russians, sent to St. Petersburg, where he had become a famous informant on things Japanese, and then finally returned to Japan. Sadanobu had wanted to see whether this artist of his, who was "so crazy about

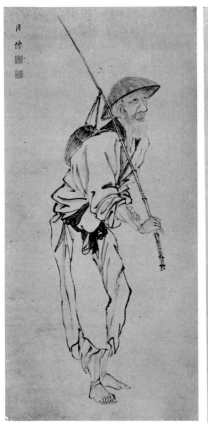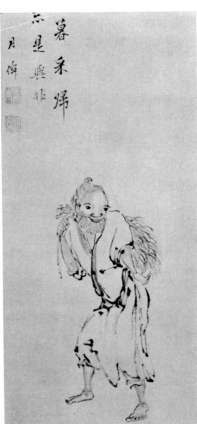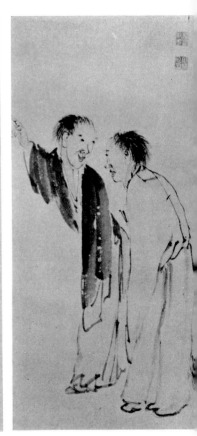

painting he would forget to eat or sleep," could come up with a more accurate reproduction than Kōkan had. The journal in which Sadanobu tells of his desire to improve on Shiba Kōkan's work gives a rather complete description of the process for making a copperplate etching, a process that does not differ in principle from that still in use today. For a dyer with the technical skill and inventiveness that Denzen undoubtedly possessed, the technical information provided by Sadanobu must have facilitated the transition from one sort of printing process to another. The main hindrance was actually the difficulty of acquiring the nitric acid necessary for etching. Its method of production was known to the coterie of "Dutch studies" scholars in Nagasaki, and a Kyoto physician had published a description of the process in 1798, but difficulties remained. This "strong water" that had the capability of dissolving metals was a fearsome liquid to the people of that time. With a word on his behalf from Sadanobu, Denzen could have obtained imported nitric acid from the shogunal physician, but at a time when even the export of copper was restricted because of the priority given to internal demands, any imported chemical was regarded as a precious substance—particularly since permission for the entry of Dutch ships had been cut back to one ship a year. All this explains why he resorted to using a bronze mirror as a substitute for copperplate, as he did to produce the print shown in plate 82, and why some of his plates are engraved on both sides.

74. *Painting of a Fisherman*, by Gessen. Ink and colors on paper. H. 123.8, w. 47.5 cm. Ise Shrine Repository, Mie Prefecture.

75. *Painting of a Farmer*, by Gessen. Ink and colors on paper. H. 91.5, w. 28 cm. Ise Shrine Repository, Mie Prefecture.

76. *Han-shan and Shih-de*, by Gessen. Ink and colors on paper. H. 102, w. 27 cm. Ise Shrine Repository, Mie Prefecture.

77–78. *Koto and Flute Ensemble*, by Aōdō Denzen. Ink and colors on paper. H. 121.7, w. 51 cm. Private collection, Japan.

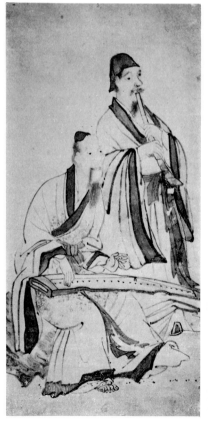

79–80. *Nighthawk*, by Aōdō Denzen. Ink and colors on silk. Private collection, Japan.

81. Impressions from two seals used by Aōdō Denzen. From *Mount Asama*. A six-fold screen. Colors on paper. H. H. 149, w. 342.4 cm. Tokyo National Museum.

82. *Horse*, by Aōdō Denzen. Engraving on a bronze mirror. D. 13.7 cm. Tokyo National Museum.

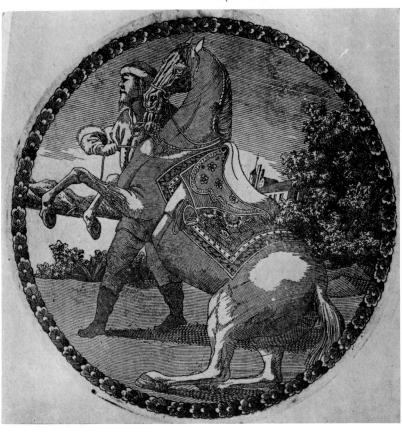

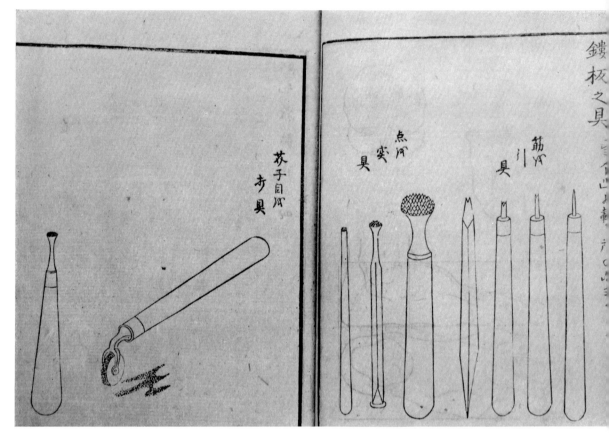

83. Pages illustrating etching and engraving implements
from the *Kōmō zatsuwa* (A European Miscellany), by Morishima
Chūryō. Woodblock prints. Reproduced from the Dutch
translation of Noël Chomel's encyclopedia. Each page h. 22.8,
w. 16 cm. 1787. Kobe City Museum of Namban Art.

SHIBA KŌKAN AND DENZEN

Although it has become clear from recent research that Denzen once studied under
Shiba Kōkan, who was his senior by one year, the passage of time made them
implacable rivals. Tanuma Okitsugu supported Hiraga Gennai and Shiba Kōkan,
whereas his rival Matsudaira Sadanobu backed Aōdō Denzen. When lined up in this
fashion, their relationships speak for themselves. Even clearer indications are to be
found in their conflicting claims for having founded the tradition of Western-style
copperplate printmaking in Japan.

Even if it were not known that Denzen had once been Kōkan's pupil, Denzen's
work would show an obvious debt. Kōkan's published explanations of linear per-
spective and shading are amply demonstrated in Denzen's work. For example, Kōkan
explains that in a frontal representation of the face the highest portion of the nose must
be left blank, and in Denzen's ink paintings the bridge of the nose is highlighted with a
touch of white. Moreover, in his *Seiyōga dan* Kōkan listed the famous coastal beauty
spots that he had depicted in Western fashion among his prints. These works were
easily available to Denzen, and Denzen did indeed do similar types of seascapes. That

84–85. Examples of Aōdō Denzen's engraved illustrations for
the *Ihan teikō* (The Essentials of Medical Instruction), by Uda-
gawa Shinsai. Each page h. 26, w. 18.3 cm. 1805. Private
collection, Japan.

Denzen was able to bring to practical fruition many of the possibilities suggested by his
scholarly predecessors was due in part to the fact that he was an artisan by training and
more interested in applications than abstract theories, an attitude fully supported by
his powerful patron. He was aided in his attention to technique by the writings of a
former pupil of Hiraga Gennai, Morishima Chūryō, whose publication titled *Kōmō
zatsuwa* (A European Miscellany; 1787) contained comments on the processes of etch-
ing and engraving (pl. 83). Chūryō subsequently entered the employ of Sadanobu in
1791, thereby coming into direct contact with Denzen.

 In 1808 Denzen was put in charge of producing illustrations for a medical text by the
noted physician and "Dutch studies" specialist Udagawa Shinsai (pls. 84–85). Accord-
ing to the colophon, copperplate illustrations were desirable for their precision, and the
writer of the colophon praised Denzen's accomplishments as an engraver. The frontis-
piece (pl. 86) was done by Denzen's pupil Arai Reikyō, and it depicts the seventeenth-
century Dutch physician Stephan Blankaerts, to whose research the work was much
indebted. The publication of this medical text established terminology of which much
is still in use today.

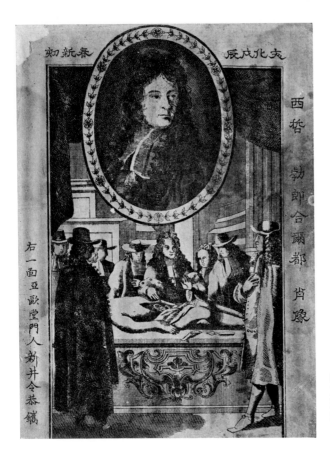

86. Engraved frontispiece, by Arai Reikyō. From the *Ihan teikō* (The Essentials of Medical Instruction), by Udagawa Shinsai. H. 26, w. 18.3 cm. 1805. Private collection, Japan.

DENZEN'S ARTISTIC ACHIEVEMENTS

In 1809 Denzen produced a large copperplate print bearing the title *View of a City Square in Germany* (pl. 87), which was based on an engraving printed in London around 1756 depicting the ruins of ancient Rome (pl. 88). Denzen's print shows the memorial stele erected to the Roman emperor Trajan, complete with its spiral-shaped carvings (upper left), but he failed to understand the nature of the building shown in the right-hand background of the imported print, so he put a peaked roof on it and relocated it in his own print. (His use of shading on the roof dormers is strictly based on Shiba Kōkan's "three-facet" principle of chiaroscuro.)

This print must have made quite a sensation when it came out, for elements were incorporated as a backdrop for the cover illustration (pl. 89) of a popular storybook designed by the *ukiyo-e* artist Utagawa Kunisada, and the design was reflected in the fanciful print titled *Fransca Cathedral in Holland* attributed to Utagawa Kunitora (pl. 90). In 1810 Denzen finished a map of the world (pl. 92) based on the work of one of his Japanese contemporaries, which, in turn, was a Japanese adaptation of a European import that bore the date 1780. The last surviving copperplate of Denzen's that bears a date is inscribed 1814 (pl. 91). It is titled *Monument to the Poet Bashō by the Ōkuma Cascade*, and was produced as a frontispiece for the anthology of poetry *Seiinshū* (A Collection of Blue Shadows) by the Sukagawa haiku poet Iwai Amenori. It reveals a rather laborious effort to catch the rush of falling water but is, nevertheless, an effective

composition.

87. *View of a City Square in Germany*, by Aōdō Denzen. Copperplate etching. H. 36.9, w. 69.6 cm. 1809. Tokyo National Museum.

88. *The Ruins of Ancient Rome*. A copperplate engraving produced in London around 1756. H. 26, w. 40.3 cm. Private collection, Japan.

89. Cover for *Shakahassō Yamato bunko* (The Eight Great Events: Japanese Edition), a popular novel; designed by Utagawa Kunisada. Woodblock print. 1845. Tokyo Metropolitan Central Library.

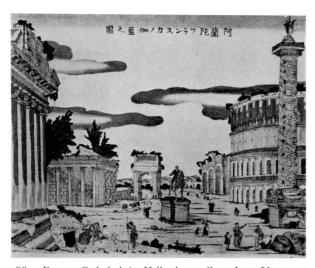

90. *Fransca Cathedral in Holland*; attributed to Utagawa Kunitora. Woodblock print. H. 24.4, w. 36.1 cm. Tokyo National Museum.

91. *Monument to the Poet Bashō by Ōkuma Cascade*, by Aōdō
Denzen. Copperplate etching. H. 23.6, w. 32.7 cm. 1814.
Tokyo National Museum.

92. *Revised Map of the World*, by Aōdō Denzen.
Copperplate etching. H. 104.5, w. 183.5 cm.
1810. Cabinet Library, Tokyo.

 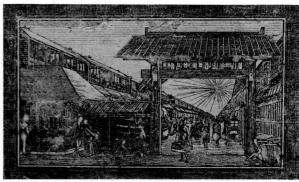

93. *View of the Mimeguri Shrine*, by Aōdō Denzen. Copperplate etching. H. 12.4, w. 16.6 cm. Tokyo National Museum.

94. *Main Entrance to the Yoshiwara District*, by Aōdō Denzen. Copperplate etching. H. 10.6, w. 15.2 cm. Tokyo National Museum.

Denzen was engaged in the regular profession of engraving and printmaking from the time when he was first called to Edo by Sadanobu in 1798, and he produced a steady succession of etchings and engravings of genre scenes of Edo as well as scenes of foreign lands. Plates 93–102, 128–29, 103–11 present an assortment of some of the scenes around Edo, grouped in a likely chronological order. These small and medium-sized prints were produced in black and white, with the exception of those reproduced in pls. 105 and 128–29, and most of them bear the "Aōdō" signature. A paper bag for containing souvenir collections of these prints, as well as the block used to print the design on the bag, is now in the collection of the Tokyo National Museum (pls. 112–13). The prints are all mounted on fringed pieces of cloth, an innovation that seems not out of place for a one-time dyer of fabrics. This rather exotic device was taken over by such *ukiyo-e* print designers as Hokusai, Hokuju, Shinsai, and Eisen.

In addition to these small and medium-sized prints, which give a clear sense of technical mastery, there remain a number of large-sized copperplate prints with powerful lines and sweeping curves whose boldness suggest that they all date from the latter part of his career, that is, from about 1805 to about 1815. Among these are *View of Sensō-ji on Mount Kinryū*, depicting the main temple on the left and the gateway on the right (pl. 114); another view of Sensō-ji, as seen from the front (pl. 116); *View of the Mimeguri Shrine* (pl. 115); *Scene in the Tea Pavilion on Mount Atago* (pl. 117); *View Southward along the Sumida River* (pl. 118); *View of a City Square in Germany*, already described (pl. 87); *View of a Western Park* (pl. 119; a representation of Hyde Park in London that may owe

105

95. *View from Mount Atago*, by Aōdō Denzen.
Copperplate etching. H. 10.6, w. 15.2 cm. Tokyo
National Museum.

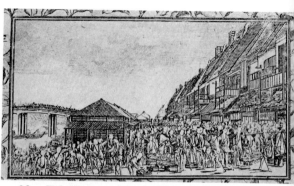

96. *Fish Market at Nihonbashi*, by Aōdō Denzen.
Copperplate etching. H. 10.6, w. 15.2 cm. Tokyo
National Museum.

97. *View of Shinobazu Lake from the Ōzuchiya*,
by Aōdō Denzen. Copperplate etching. H. 10.6,
w. 15.2 cm. Private collection, Japan.

98. *Firing Tiles at Imado*, by Aōdō Denzen.
Copperplate etching. H. 10.6, w. 15.2 cm.
Private collection, Japan.

something to Shiba Kōkan's depiction of the Serpentine lake in the same location,
pl. 57); *The Queen of Spain Granting an Audience to Columbus* (pl. 120); and *Dragons in the
Clouds* (pl. 122).

The strength and grandeur of these compositions and their linear freedom are some-
thing new, and certainly not to be found in the etchings of Shiba Kōkan. These full-
sized prints are free from the confinements of the peep-show scenic cards imported from
Europe that had provided subject matter and set stylistic limitations for Shiba Kōkan.
Denzen's late work shows him to be fully at home in both the technique of the copper-
plate engraving and the conventions of Western drawing. The principles of linear
perspective and shading are blended in a unified style; and even the bird's-eye scenic
views are free from any residue of traditional Chinese perspective.

Somewhere around 1814, or shortly thereafter, Denzen left his lord's mansion in Edo
and returned to his birthplace, Sukagawa, concluding a twelve-year stay in the shogunal
capital. At the urging of a friend who ran a dry goods store, Denzen produced souvenir
etchings for his friend to sell. In front of the shop, the Engyoku-an, a conspicuous oak
signboard was suspended with the inscription "Master Aōdō Denzen, Founder of the
Tradition in Japan, On-the-Premises Production of the Famous Copperplate Prints"
(pl. 121). Denzen used his copperplate technique for printing cloth souvenir objects
such as kimono undercollars (pl. 125; from the same plate used for the print in pl. 122)
and handbag linings as well as regular picture prints. The material lining the inside of
the handbag in plate 123 is imprinted with the same violin design that survives in the

106

99. *View of the Confucian Academy from Kanda-bashi*, by Aōdō Denzen. Copperplate etching. H. 10.6, w. 16.1 cm. Tokyo National Museum.

100. *View of the Mannen and Ōhashi Bridges*, by Aōdō Denzen. Copperplate etching. H. 10.6, w. 15.2 cm. Private collection, Japan.

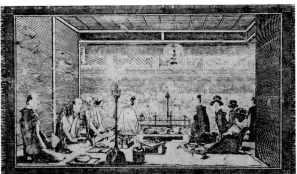

101. *View of Suidō Bridge from Surugadai*, by Aōdō Denzen. Copperplate etching. H. 10, w. 15.2 cm. Tokyo National Museum.

102. *Scene in the Shin'yoshiwara on the Night of the Niwaka Festival*, by Aōdō Denzen. Copperplate etching. H. 10.6, w. 15.2 cm. Tokyo National Museum.

form of a conventional print (pl. 124). This print is found in the album *Dōbangashū* (Collection of Copperplate Prints), which further illustrates Denzen's versatility and restless curiosity. Plate number eight in the album is a copy of the title page of a Dutch publication dated 1791, but with "Michinoku Sukagawa Aōdō Denzen" inscribed at the top in improvised Romanization (pl. 126). The album also includes a more Oriental design of sparrows amid ripened ears of rice (pl. 127).

Denzen tried to get his only son to follow in his footsteps and master the secrets of Western-style printmaking, but after a short apprenticeship the young man turned to the fashionable medical profession, then became dissolute in his ways, wandering from place to place drinking heavily. Denzen died in 1822, and his son survived him by only six years.

It was in 1740 that the eighth shogun, Yoshimune, looked through a Dutch book with engraved illustrations, admired the precision of workmanship in the illustrations, and ordered that the book be translated. A few years prior to that, the same Yoshimune had given three Nagasaki interpreters permission to begin the serious study of the Dutch written language, and it was only sixty-odd years from that time, in 1805, that Aōdō Denzen brought copperplate etching to full technical realization. Shiba Kōkan and Denzen had accomplished this through self-instruction from texts written in a language that no one had been able to read a few decades earlier.

103. *Map of All the Famous Places of the Eastern Capital*,
by Aōdō Denzen. Copperplate etching. H. 10.6,
w. 15.2 cm. Tokyo National Museum.

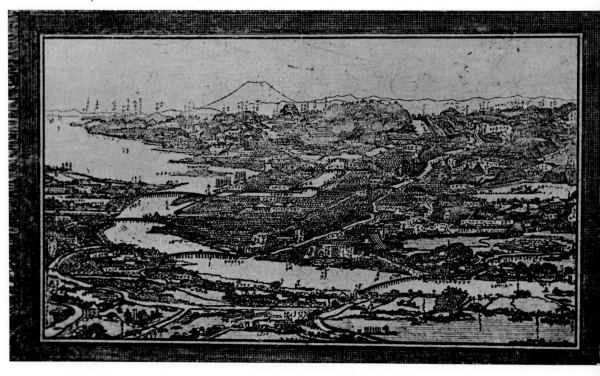

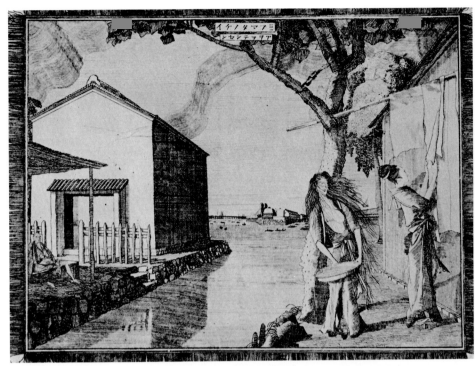

104. *View of Mitsumata*, by Aōdō Denzen. Copperplate etching. H. 21.4, w. 28.1 cm. Private collection, Japan.

105. *Shrine of Benten at Suzaki*, by Aōdō Denzen. Copperplate etching. H. 26.1, w. 34.5 cm. Tokyo National Museum.

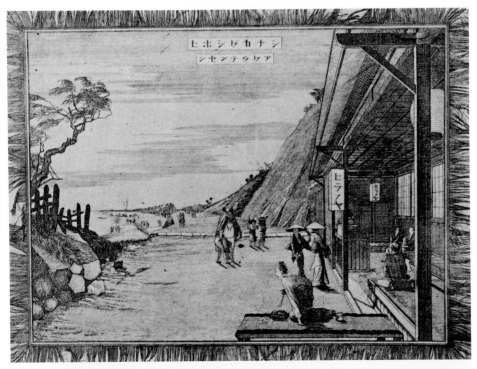

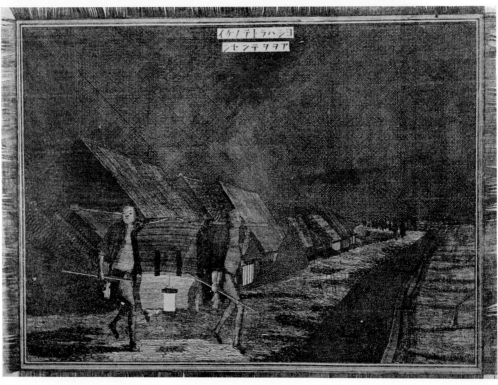

106. *Low Tide at Shinagawa*, by Aōdō Denzen. Copperplate
etching. H. 22.4, w. 28.4 cm. Tokyo National Museum.
107. *Dike at Yoshiwara*, by Aōdō Denzen. Copperplate
110 etching. H. 22.2, w. 34.2 cm. Tokyo National Museum.

108. *View of Enokizaka*, by Aōdō Denzen. Copperplate etching. H. 22.7, w. 26.4 cm. Tokyo National Museum.
109. *Approach to Eitai Bridge*, by Aōdō Denzen. Copperplate etching. H. 22.7, w. 29.1 cm. Tokyo National Museum.

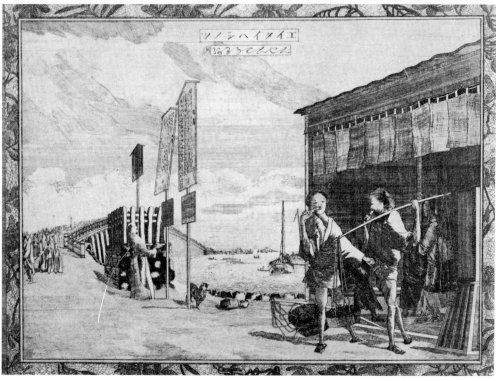

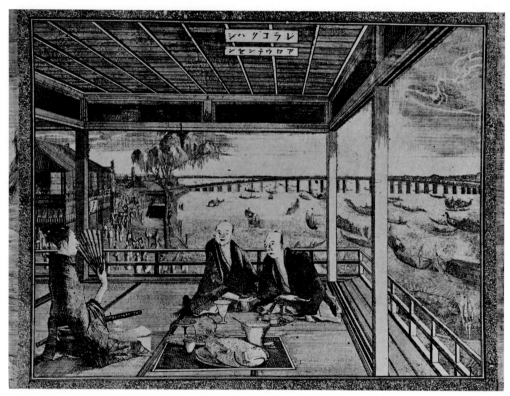

110. *Ryōgoku Bridge*, by Aōdō Denzen. Copperplate
etching. H. 21.8, w. 28.2 cm. Tokyo National Museum.

111. *Scene at Shinobazu Lake*, by Aōdō Denzen. Copper-plate etching. H. 24.5, w. 36.4 cm. Tokyo National Museum.

112–13. A paper bag used as a wrapper for a set of souvenir prints by Aōdō Denzen and the woodblock used for printing the cover design. Tokyo National Museum.

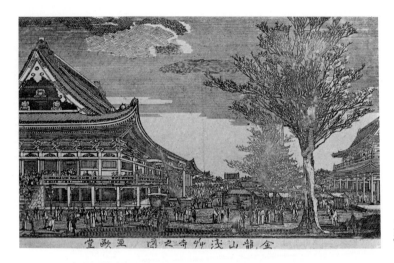

堂欧亜　図之寺クサ浅山龍金

114. *View of Sensō-ji on Mount Kinryū*, by Aōdō Denzen. Copperplate etching. H. 15.1, w. 21.2 cm. Tokyo National Museum.

115. *View of Mimeguri Shrine*, by Aōdō Denzen. Copperplate etching. H. 23.9, w. 31 cm. Tokyo National Museum.

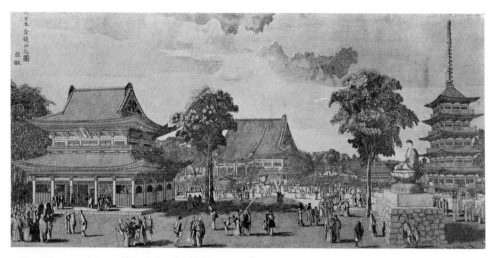

116. *Scene on Mount Kinryū*, by Aōdō Denzen. Copperplate etching. H. 29.6, w. 56.7 cm. Private collection, Japan.

117. *Scene in the Tea Pavilion on Mount Atago*, by Aōdō Denzen. Copperplate etching. H. 26, w. 38.1 cm. Tokyo National Museum.

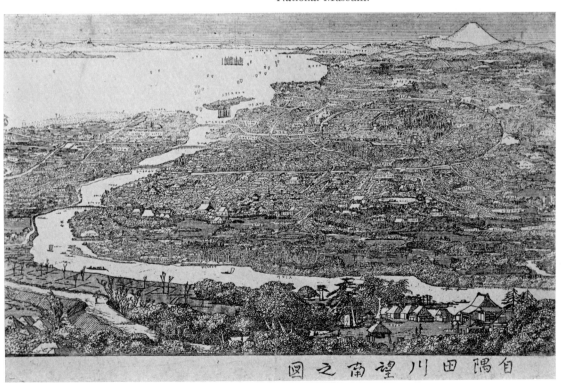

118. *View Southward along the Sumida River*, by Aōdō Denzen. Copperplate etching. H. 15.1, w. 21.2 cm. Tokyo National Museum.

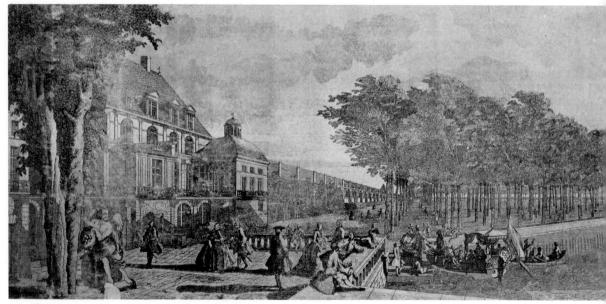

119. *View of a Western Park*, by Aōdō Denzen.
Copperplate etching. H. 27.2, w. 53.9 cm. Tokyo
National Museum.

120. *The Queen of Spain Granting an Audience to
Columbus*, by Aōdō Denzen. Copperplate etching.
H. 37.2, w. 32 cm. Tokyo National Museum.

121. Signboard that hung in front of a shop selling souvenir etchings by Aōdō Denzen in Sukagawa. H. 146, w. 52.5 cm. Private collection, Japan.

122. *Dragons in the Clouds*, by Aōdō Denzen. Copperplate etching. H. 33.3, w. 45.5 cm. Tokyo National Museum.

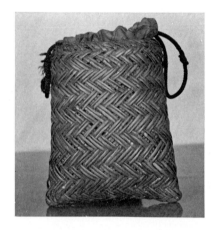

123. Handbag of basketwork and cloth. Cloth design from an etching by Aōdō Denzen. H. 24, w. 16 cm. Sukagawa Municipal Education Commission, Fukushima Prefecture. (See pl. 124 for the design on the cloth as a print.)

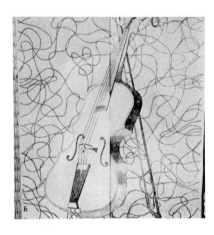

124. *Violin*, by Aōdō Denzen. Copperplate etching. H. 36, w. 24.5 cm. Private collection, Japan.

125. A kimono undercollar printed from an etching plate made by Aōdō Denzen. H. 19, w. 93 cm. Private collection, Japan. (For an impression on paper from the same copperplate, see pl. 122.)

127. *Sparrows and Ripened Ears of Rice*, by Aōdō Denzen. Copperplate etching. H. 36, w. 24.5 cm. Private collection, Japan.

126. Aōdō Denzen's version of the title page of a Dutch publication dated 1791. Copperplate etching. H. 36, w. 24.5 cm. Private collection, Japan.

119

128. *Exact Depiction of Tsukudajima*, by Aōdō Denzen. Copperplate etching with colors added. H. 10.6, w. 16.4 cm. C. 1810. Tokyo National Museum.

The Tsukudajima district of Edo (modern Tokyo) derived its name from the fact that it was first settled by fishermen from Tsukuda Village near Osaka who were granted fishing rights in Edo as a reward for manning boats for the first Tokugawa shogun. Unlike Shiba Kōkan, Denzen seldom colored his prints, as he has here. Denzen's work is notable instead for the precision of the lines and the skillful control of the etching acid.

129. *View of Ryōgoku*, by Aōdō Denzen. Copperplate etching. H. 10.6, w. 16.1 cm. C. 1810. Tokyo National Museum.

Denzen used many subjects that Shiba Kōkan had dealt with previously, but Denzen was able to convey a feeling for the bustling activity of these places. This print and the one in plate 128 are thought to date from around 1810.

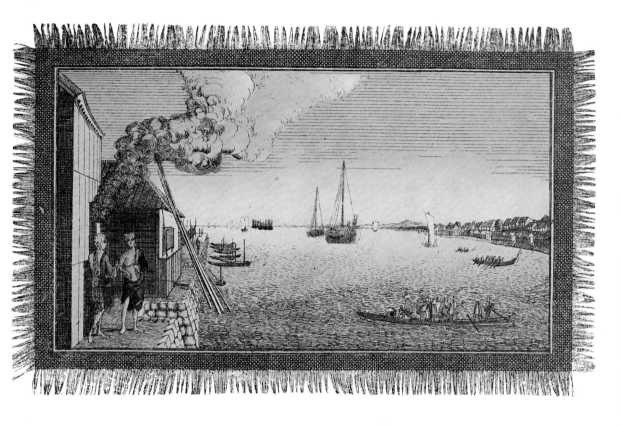

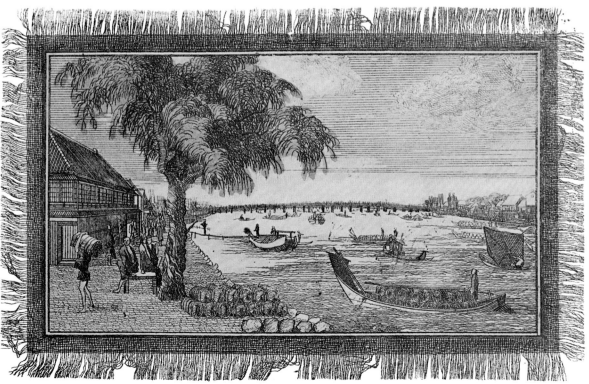

8

DENZEN'S SUCCESSORS AND WESTERN-STYLE WOODCUT MASTERS

Yasuda Denki and Yasuda Raishū

Among the pupils of Aōdō Denzen are listed such names as Arai Reikyō, Endō Den'ichi, and Yasuda Denki. Denki (1784–1829) was from the northern town of Sendai, but he moved to Sukagawa, became a resident artist in the household of the lord of Shirakawa, and studied not only under Denzen, but also under Haku'un and Tani Bunchō, as had Denzen himself. Among his extant works, aside from some paintings, is a copperplate dated 1815 that depicts a pavilion known as the Kangyotei, part of a villa of one of the officials in service to the lord of Shirakawa (pl. 134). However, no great number of paintings or prints attributable to Denzen's pupils have survived, and this may have been because they were rather overwhelmed by Denzen himself, or perhaps because an official coolness toward nonutilitarian drawing in the Western style was having an influence in the provinces.

A somewhat later engraver by the name of Yasuda Raishū also worked in the tradition of Denzen. Although his exact dates are uncertain, it is known that he was active as late as the great earthquake of 1855, which he used as the subject of a painting. Another painting of his bears an inscription dated 1858, indicating that he was alive after Commodore Perry's opening of Japan to Western commerce and diplomacy in 1854. Raishū was known as both an engraver and an illustrator of block-printed novels, and in 1844 he did a series of etchings of the fifty-three waystations of the Tōkaidō (pls. 139–42), a subject best known from Hiroshige's interpretations, whose popularity at this time undoubtedly had something to do with Raishū's choice of subject. This series, which typifies Raishū at his best, does in fact show stylistic influences from the woodcut genre.

Contemporary chronicles indicate that he had a reputation as a Western-style painter as early as the beginning of the nineteenth century, though evidence in the form of paintings to support this has not survived. He used the name "Yasuda Sadakiti, William van Leiden," spelled out in Roman letters, intending to associate himself with the early sixteenth-century Dutch painter Lucas van Leyden. Between 1821 and 1823 he produced a series of famous places around Edo, numbered from one to twelve. In numbers two (*View from Senrihara;* pl. 136) and six (*Scene at Ryōgoku Bridge;* pl. 135) the horizon is low and the field of vision wide, a style reminiscent of Dutch landscape paintings. It seems likely that the somewhat panoramic bird's-eye perspective found

in his landscapes was influenced by Hokusai, whose pupil he once was. As a continuation of Aōdō Denzen's practice of mounting his prints on fringed fabric, Raishū used borders ornamented with insect designs (pl. 135).

A contemporary novel mentions this series in its foreword, commenting that while Raishū depicts the scenery of Edo, he leaves the viewer with the impression that he has journeyed to a foreign land, or that a Dutchman has come to Japan and rendered his impressions of the Japanese landscape.

Matsumoto Yasuoki

Matsumoto Yasuoki (1786–1867), otherwise known as Matsumoto Gengendō, was born in Kyoto into a merchant family. In 1836 he produced a copperplate map of the world, and decided to take that occasion to desert his family calling, like Aōdō Denzen, and become an artist. At about the same time he produced a print of the temple known as Jakuō-ji near Kyoto, which gives evidence of his having used the aquatint technique in preparing the plate, though there is some uncertainty as to how he learned the method and under whom he studied. The art of copperplate engraving was making its way from Edo to Nagoya to Kyoto, perhaps partially in response to the fact that in Edo, in the early 1840s, fear of an invasion of Japan's seclusion was causing suspicion to fall on the pro-European activities of the "Dutch studies" specialists.

Whatever the fear of official disfavor may have done to the activities of the encyclopedists and internationalists in Edo, Yasuoki's production was considerable, to judge from the number of his engravings that have survived. They include the customary famous scenes of Japan and such exotica as the sacred Vulture Peak in India, the Colossus of Rhodes, European naval engagements, and a portrait of Louis XIV. His special series of miniature engravings depicting famous scenes of Kyoto and Osaka date from 1862, and show such things as paddle-wheel steamers and steel bridges along with traditional subjects, indicating how suddenly the Japanese landscape was being altered (pl. 138).

His son, who was known as Matsuda Rokuzan, or Gengendō II, learned the engraver's trade from his father. As a specialist in one of the newly important Western technologies he was employed by the imperial government after the Meiji Restoration and moved to the new capital, Tokyo. (For a single example of his technical skill as a maker of reproductive engravings, see pl. 137.)

Western-style Block Prints

In Paris in the eighteenth and nineteenth centuries there were many popular specialty establishments producing optical viewing devices and special engravings to be viewed through them. The practice of viewing pictures through an optical device came to China as early as the seventeenth century, and a Chinese publication dated 1684 makes

130. *Festivities at Shijōgawara*, by Maruyama Ōkyo. Woodblock print with colors added. H. 21.3, w. 27.2 cm. C. 1759. Private collection, Japan.

On the basis of the theatrical advertisements displayed in front of the Minamiza Theater, this print can be dated at about 1759. This view-box print, which is a mirror image, was block printed and then colored by hand. The young Ōkyo designed prints of this sort as a sideline to his employment in a toy store where the view-boxes were sold.

131. *Archery at the Sanjūsangen-dō*, by Maruyama Ōkyo. Woodblock print with colors added. H. 20, w. 26.4 cm. C. 1759. Private collection, Japan.

This is a hand-tinted view-box perspective print intended to create a special illusion of depth. The building that now bears the name "Sanjūsangen-dō" is a later reconstruction, famous for its extensive collection of Kamakura-period Buddhist sculpture.

132. *View from Kiyomizu-dera*, by Maruyama Ōkyo. Woodblock print with colors added. H. 20.5, w. 28 cm. C. 1759. Private collection, Japan.

The exaggerated perspective of the optical-illusion prints is here attenuated by the low-lying city of Kyoto that intervenes between the temple and the mountains in the distance.

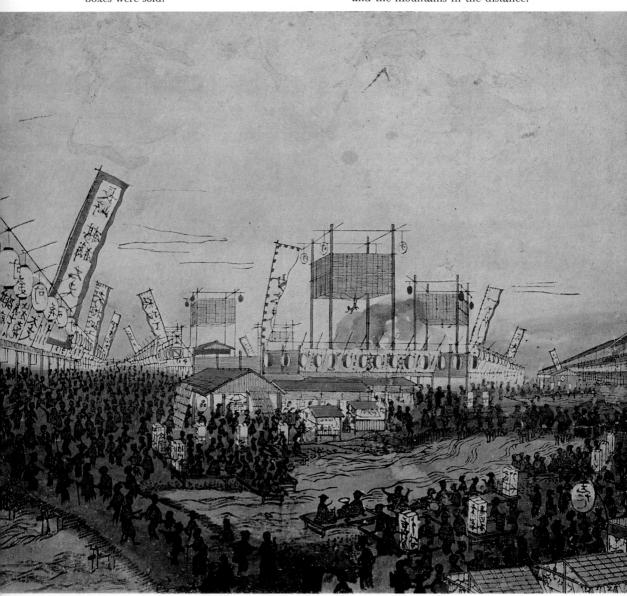

mention of such devices. In the city of Soochow, woodcuts employing linear perspective and intended for such viewing were produced in quantity, and before long these "Soochow prints" were introduced into Japan (pl. 143). As early as 1686 the technique of lens grinding had been mastered by an artisan in Kyoto, and by 1718, according to a Japanese chronicle, for a single copper coin one could look into an optical device and "see the scenery of heaven and hell." The description makes it evident that at this time individually produced paintings, rather than prints, were used in these devices.

In time, under the influence of the paintings and prints that were produced for these viewers, a type of "perspective" print or *uki-e* ("floating picture") came into existence, whose exaggerated converging lines were intended to produce the optical illusion of deep recession without benefit of lenses and mirrors. These perspective prints, which were greeted with wonderment and enthusiasm, were regarded as a special artistic genre, and soon they began to depict Japanese scenes rather than just the Chinese and European exotica of the viewing-device prints. The *ukiyo-e* block-print master Okumura Masanobu (1686–1764), who credited himself with being the originator of the Japanese perspective print, produced a large number of these in the 1720s and 1730s, and they had a profound influence on the future development of Japanese prints in general.

Actually the real perfector of the view-box picture was the versatile experimenter in Western-style painting Maruyama Ōkyo (1733–95). As a young man he had worked for a very well established Kyoto toy merchant, and in this connection he had become interested in the optical view-box and, around 1760, started to produce woodcuts for this purpose. Among these were *View of the Ten-Thousand-Year Bridge at Kusu, Kiangsu Province, China* (pl. 144), *Festivities at Shijōgawara* (pl. 130), *Archery at the Sanjūsangen-dō* (pl. 131), *View from Kiyomizu-dera* (pl. 132), *The Vendetta of the Loyal Samurai of Akō* (pl. 145), and many others, including a series on famous places and another on annual celebrations.

The viewing devices for which these perspective paintings and prints were produced consisted of a simple box or frame with a peephole. Later, people peered through lenses, and finally a mirror was incorporated that required the use of reversed or mirror-image pictures. The print reproduced in plate 130 is clearly of this sort since all the writing on the banners and lanterns is backwards. It is said that commercial peepshows using these devices were to be found at temple fairs until fairly recent times.

KATSUSHIKA HOKUSAI

According to one of his earlier biographers, Katsushika Hokusai (1760–1849) apprenticed himself to Shiba Kōkan in the 1790s in order to learn oil painting and copperplate engraving, but this seems to be historically very uncertain. In 1815 he published his famous fourteen-part *Hokusai manga* (Hokusai Sketchbooks), a vast compilation of drawings, sketches, and cartoons. Part three of this work does contain a diagram depicting the laws of linear perspective as set forth by Gerard de Lairesse (pls. 146–47;

Hokusai could not resist adding unrelated cartoons to the bottom of the pages), but the information contained in these diagrams could easily have been acquired through his contacts with the *ukiyo-e* master Katsukawa Shunshō, under whom Hokusai studied, or through his own inquisitiveness. The influence of Western drawings and techniques is also evident in the series *Eight Scenes from Edo* (pls. 148–51), which not only employs European perspective principles but also shows that Hokusai was experimenting with the stylistic language of the copperplate engraver even while designing for a block-print series. It seems likely that Hokusai at least came in contact with Shiba Kōkan's ideas by reading some of his writings. In 1848, when Hokusai was eighty-eight—one year before his death—he published a book on painting techniques for the beginning student that gives a fragmentary account of Western styles, including a description of the process for making copperplate etchings.

A clear sense of Hokusai's ability to assimilate and apply Western principles is evidenced in such close-ups as his *Gateway to the Shin'yoshiwara Licensed Quarter* (pl. 152), his panoramic *View of Jūnisō in Yotsuya* (pl. 133), and his famous *Thirty-six Views of Mount Fuji*. In his eighty-ninth year this "old man mad with painting" laid down his brush for the last time. After his death the winds of historical change began to blow harshly across the land.

HOKUSAI'S CONTEMPORARIES

Among those who studied under Hokusai was Shōtei Hokuju (1763–1824), who was active in the production of perspective prints around the turn of the century. He showed some uncertainty in his control of the principles of perspective, as can be seen in the steps leading up to the temple in his *View of Zōjō-ji at Maruyama in Shiba* (pl. 155) and in the roofs and steps of his *Shinagawa as Seen in the Distance from Mount Atago* (pl. 154), but there is an explanation for this bold use of distortion, since even his master Hokusai often did not follow the rules of perspective exactly. Another occasional experimenter with perspective prints of a somewhat earlier period was the *ukiyo-e* master and teacher Kitao Shigemasa (1739–1820). One such print bears the label *Evening Scene in the Home of a Nobleman* (pl. 156). Shigemasa, whose family had been in the publishing business, was in a good position to encounter and make use of new ideas.

Among other *ukiyo-e* masters who experimented with perspective prints were several members of the Utagawa school, notably Utagawa Toyoharu (1735–1814), who produced a large number of perspective prints using intense colors in the Chinese style (pls. 157, 160). Another member of the school was Utagawa Toyohisa, whose fanciful and improbable view of Ryōgoku Bridge (pl. 161) shows a late development of the *uki-e* or perspective print. Other followers of the Utagawa tradition who showed great individuality were Utagawa Kunitora, active from about 1803 to about 1844, and the famous Andō Hiroshige (1797–1858). Kunitora's prints show a strong feeling of recession and a powerful use of color that is most unlike the traditional Japanese print (pls. 158–59). 127

133. *View of Jūnisō in Yotsuya*, by Katsushika Hokusai. Woodblock print. H. 16.8, w. 22.8 cm. 1804. Tokyo National Museum.
This print, dated 1804 and thus done well before his famous series *Thirty-six Views of Mount Fuji*, shows the concern he had already developed for mastering the principles of linear perspective and, at the same time, illustrates his dramatic vision of the beauties of nature.

Andō Hiroshige also managed to free himself from the conventions of the perspective print, though by quite different means. He expressed a freshness of vision through his direct apprehension of nature. The truly unusual angle of vision displayed in his *Evening Moon at Ryōgoku Bridge* (pl. 153) was copied directly by James McNeill Whistler in one of his oil paintings. The rapid changes that were coming over *ukiyo-e* as the result of the stylistic inventions of Hiroshige were only a foretaste of the revolutionary changes that were to be ushered in by the Meiji Restoration.

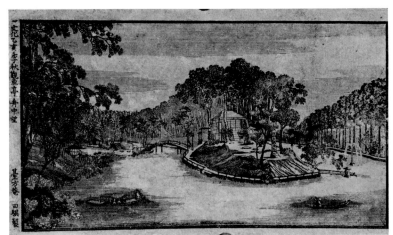

134. *Kangyo Pavilion*, by Yasuda Denki. Copperplate etching. H. 12, w. 21.3 cm. Private collection, Japan.

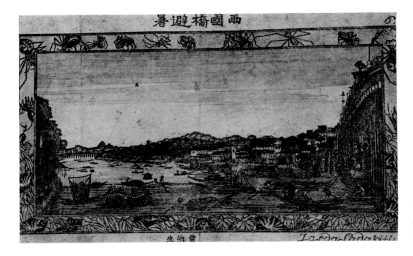

135. *Scene at Ryōgoku Bridge*, by Yasuda Raishū. Copperplate etching. H. 11.3, w. 20 cm. Private collection, Japan.

136. *View from Senrihara*, by Yasuda Raishū. Copperplate etching. H. 11.3, w. 20 cm. Private collection, Japan.

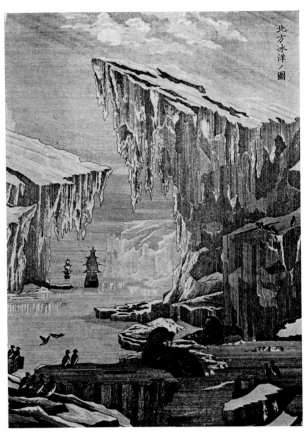

北方冰洋ノ図

137. *Ice in the Arctic Ocean*, by Matsuda Roku-zan. Copperplate engraving. H. 20.2, w. 14.7 cm. Private collection, Japan.

138. *Famous Scenes of Kyoto and Osaka*, by Matsumoto Yasuoki. Details. Copperplate etchings. 1862. Private collection, Japan.

139–42. Prints from the series *Fifty-three Waystations of the Tōkaidō*, by Yasuda Raishū. From top: *Kusatsu, Ōtsu, Sanjō, Gion*. Copperplate etchings. Each h. 13, w. 19.9 cm. 1844. Tokyo National Museum.

143. *Chinese Landscape*. Woodblock print. Published in Soochow. H. 21, w. 28 cm. Private collection, Japan.

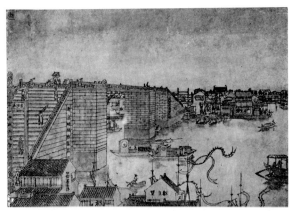

144. *View of the Ten-Thousand-Year Bridge at Kusu, Kiangsu Province, China*, by Maruyama Ōkyo. Woodblock print. H. 21.1, w. 27.1 cm. Private collection, Japan.

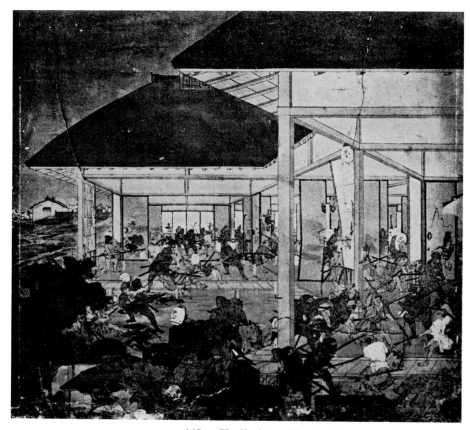

145. *The Vendetta of the Loyal Samurai of Akō*, by Maruyama Ōkyo. Woodblock print. H. 25.9, w. 28.4 cm. Private collection, Japan.

146–47. Two pages from the *Hokusai manga* (Hokusai Sketchbooks), by Katsushika Hokusai. Woodblock prints. 1814–79. Tokyo National Museum.

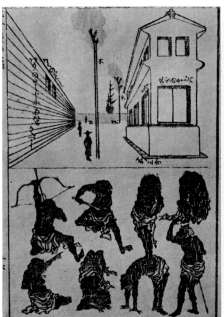

152. *Gateway to the Shin'yoshiwara Licensed Quarter*, by Katsushika Hokusai. Woodblock prints. H. 24, w. 35.3 cm. Tokyo National Museum.

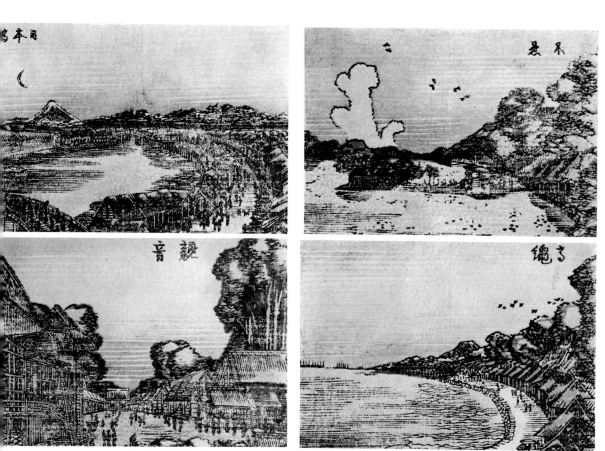

148–51. Prints from the series *Eight Scenes from Edo*, by Katsushika Hokusai. Clockwise from upper left: *Nihombashi, Shinobazu, Takanawa, Kannon*. Woodblock prints. Private collection, Japan.

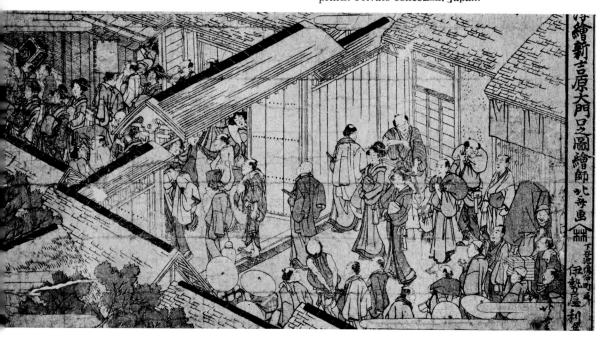

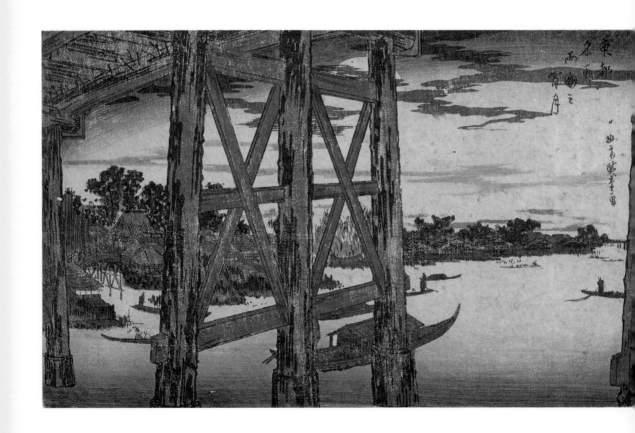

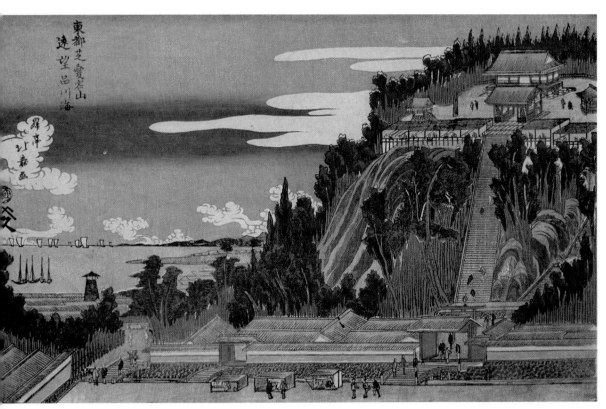

154. *Shinagawa as Seen in the Distance from Mount Atago*, by Shōtei Hokuju. Woodblock print. H. 25, w. 38 cm. 1820. Homma Art Museum.
Hokuju was a pupil of Hokusai's and shared his enthusiasm for bold landscape depictions. In the first few years of the nineteenth century he designed perspective prints, but, as one can see here, he distorted considerably the perspective principles he was trying to master.

153. *Evening Moon at Ryōgoku Bridge*, by Andō Hiroshige. From the series *Famous Places in the Eastern Capital*. Woodblock print. H. 25, w. 37.6 cm. Tokyo National Museum.
This print was designed somewhat prior to the first production of Hiroshige's famous series *Fifty-three Waystations of the Tōkaidō* in 1833 and 1834, but about the time that Hokusai's *Thirty-six Views of Mount Fuji* had gained great popularity. The influence of such Hokusai productions as *Mount Fuji from Takahashi* and *Beneath the Mannen Bridge at Fukugawa* can be seen in this print, but Hiroshige, while lacking some of Hokusai's forcefulness, transcends the limitations of the conventional perspective print and expresses a profound appreciation for natural beauty. This print was greatly admired by James McNeill Whistler, who used it as the basis for an oil painting.

139

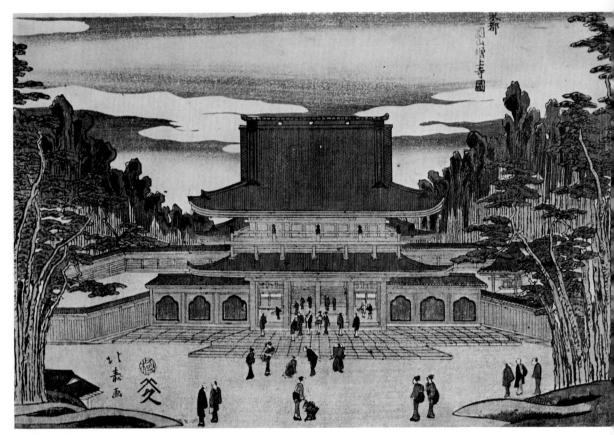

155. *View of Zōjō-ji at Maruyama in Shiba*, by Shōtei
Hokuju. Woodblock print. H. 26, w. 37.1 cm. Private
collection, Japan.

156. *Evening Scene in the Home of a Nobleman in the Perspective-Print Style*, by Kitao Shigemasa. Woodblock print. H. 13.8, w. 15.6 cm. Tokyo National Museum.

157. *Exotic Scene of Snow-Viewing in the Per-
spective-Print Style*, by Utagawa Toyoharu.
Woodblock print. H. 24.5, w. 36.4 cm. Riccar
Art Museum.

The Japanese title uses the descriptive term
oranda, or "Holland," to refer to a print in the
Western style, but the extensive use of Chinese
stylistic elements here suggests the transmission
of perspective principles to Japan via Chinese
prints that used an adaptation of Western
principles of perspective.

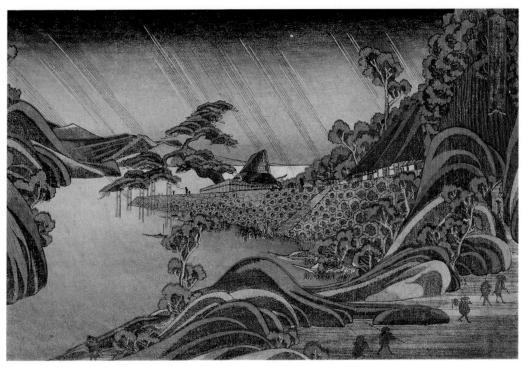

158–59. *Evening Snow at Mount Hira* (above) and *Evening Rain at Karasaki* (below). From the series *Eight Views of Ōmi Province*, by Utagawa Kunitora. Woodblock prints. Each h. 22, w. 33 cm. Private collection, Japan.

Kunitora studied under the *ukiyo-e* master Utagawa Toyokuni, but he developed his own highly individualistic style with a strong sense of recession and an emphatic use of color for strong contour delineation.

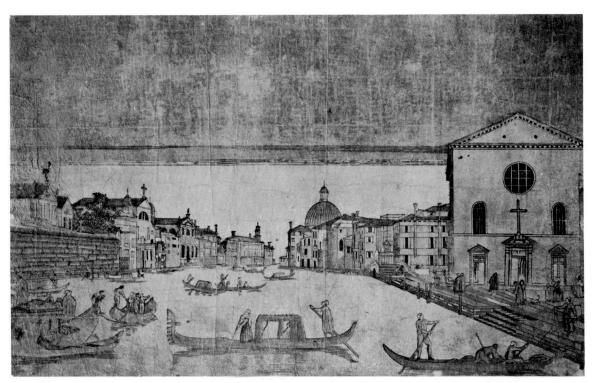

160. *Scene in Venice*, by Utagawa Toyoharu. Woodblock
print. H. 23.9, w. 36.1 cm. Tokyo National Museum.

161. *View of Ryōgoku Bridge in the Perspective-Print Style*, by Utagawa Toyohisa. Woodblock print. H. 23, w. 35.4 cm. Private collection, Japan.

CONCLUSION

We have seen the development of the Nagasaki block print, with its ties to the special position of Nagasaki as Japan's only contact with the outside world. We have observed Hiraga Gennai in his transmission of the European enlightenment to his Japanese colleagues, and have seen the beginning of copperplate etching in Japan, as achieved by Shiba Kōkan, with its full development under Aōdō Denzen. Finally we have followed the influences of illusion-creating viewing devices on the incorporation of scientific linear perspective into the tradition of the *ukiyo-e* woodblock print. The process by which these men took on European influences varied, but we do not find a mere copying of European printmaking, any more than we do in other areas of art that came under Western influence. Furthermore, circumstances forced most of the innovators in printmaking to be largely self-taught. They did offer one another help, but it was experimentation and determination that brought them through. Kōkan got his results through the assistance of Dutch-language specialists, and Denzen also relied on informants. But even then the process was tedious. Plates were soaked in acid and then hung out overnight, but still the lines were not bitten very deeply. Technical difficulties, however, did not dampen the enthusiasm for the new medium, and these artists began to look to familiar scenes for subjects to depict.

The carvers of woodblocks were unable to produce the cross-hatching and shading lines that provided so much visual realism in etchings, but Maruyama Ōkyo overcame this difficulty by hand-coloring and shading his view-box block prints. Some of the *ukiyo-e* artists tried to apply the laws of linear perspective without adequate schooling and ended in failure, but Hokusai took these principles and through his own methods achieved highly individualistic results.

Hiroshige achieved a special vision of the Japanese landscape by the use of color to suggest recession, and Kunitora powerfully represented the masses seen in nature with the shaping of his patches of color. All these artists were creative geniuses who expanded the possibilities of the traditional block print. In light of these considerations, the comments about the national character of the Japanese, as set forth in the first chapter of this book in quotations from Paul Claudel and Elie Faure, must be rejected as somewhat superficial. The process of absorption must always be one of

enterprise and selection—participation combined with originality and enthusiasm for the new tempered by a concern for proper application. The Western studies enthusiasts of the Edo period have set us a good example in all these regards.

<div align="center">NOTES TO TEXT</div>

Page 71

1. Original French title: *Dictionnaire oeconomique, contenant divers moyens d'augmenter son bien, et de conserver sa santé;* revised edition published in 1741. Dutch translation of 1743 titled *Huishoudelijk Woordenboek, Vervattende Veele middelen om zijn Goed Te Vermeerderen, en zijne Gezondheid Te Behouden;* revised Dutch translation of 1778 titled *Algemeen Huishoudelijk-, Natuur-, Zedekundigen Konst-Woordenboek, Vervattende Veele middelen om zijn Goed Te Vermeerderen en zijne Gezondheid Te Behouden.*

Page 71

2. Kōkan here mistakenly refers to the author as "Boisu" (also written "Hoisu"). This misunderstanding results from his taking the first word of the 1743 Dutch translation as incorporating the author's name. Some scholars assert that "Boisu" refers to Egbert Buys and his instruction book on the arts and sciences *Nieuw in Volkomen Woordenboek van Konsten en Weetenschappen* (1769), which was known to Kōkan. The scholar Sugano Yō has shown, however, that this book concentrates on the newer techniques that had developed since the fifteenth century, such as mezzotint, and thus did not offer as much practical help as it might have.

COPPERPLATE PRINTMAKING

The history of copperplate printmaking is long and complex, and the recent trend toward monotype techniques that produce only a single impression has further complicated the criteria of what constitutes a print. The following discussion attempts to outline basic distinctions and processes in the hope that it will further the reader's understanding of copperplate printmaking in Japan of the nineteenth century. For much of the information presented here the author is indebted to Sugano Yō's *Dōbanga no gihō* (Techniques of Copperplate Printmaking; see Bibliography).

Copperplate printmaking techniques fall into two basic categories: the directly incised method and the acid-etched method. The direct method includes three subcategories.

The first is known as dry point. The design is scratched into the copperplate with the sharpened point of a round steel needle or an instrument with a diamond, sapphire, or other hard mineral tip. Because of the round point a burr is produced on both sides of the incised groove and this makes for a soft-edged printed line. This technique was introduced in Germany and Italy at the beginning of the sixteenth century.

The second subcategory is known as mezzotint. With a spurred rocking instrument the entire surface of the plate is covered with countless burrs, and after the surface has been roughened to the point where it would print an almost solid black, scrapers and burnishers are used to smooth off the light areas of the design. This technique began in Holland at the start of the seventeenth century.

The third is known as engraving. An engraving is made with a burin, an instrument with a flat round handle and a steel shaft with a diamond-shaped cross section that is bevelled to a sharp point, which is pushed across the surface of the plate. The point can produce extremely fine lines—as fine as one-third the diameter of a human hair, or, it is said, a thousand lines in 2.5 cm. The technique started in Florence in the fifteenth century.

In the acid-etching process, the second category of copperplate printmaking, the etching needle penetrates the ground or acid-resistant coating of the metal plate and exposes lines that are bitten to various depths depending on the length of time in the acid bath. In the early sixteenth century this technique was employed with steel plates by such artists as Albrecht Dürer (1471–1528), whose steel etching *The Cannon* (pl. 162) shows a lack of variation in tone and a certain harshness of line. The first one to succeed in fully developing these methods for copperplate etching was Lucas van Leyden (1494–1533). He mastered the techniques of representing subdued lighting and atmospheric qualities in landscapes, and it was his technical contribution to Dutch landscape and seascape etchings that must have made such a profound impression on Shiba Kōkan and Aōdō Denzen. The seventeenth-century French master Abraham Bosse wrote extensively on technical aspects of printmaking, and his writing, translated into Dutch, was of great stylistic and technical importance to the copperplate artists of the Edo period, particularly Kōkan and Denzen, in their search for chiaroscuro and atmospheric effects.

162. *The Cannon*, by Albrecht Dürer. Steel-plate etching. H. 21.7, w. 32.2 cm. 1518.

163–64. Two sides of an etched copperplate (*Myths* and *The Taga Castle Monument*), by Aōdō Denzen. Each. h. 28.8, w. 24.2 cm. Private collection, Fukushima Prefecture.

As mentioned earlier in the text, the *Virgin and Child* from the Ōura Tenshu-dō (pl. 5) was made by foreign missionaries from a plate whose surface was incised with a burin, and is therefore a copperplate engraving, the first to be made in Japan. In 1783 Shiba Kōkan made the first etching by a Japanese when he covered a copperplate with wax as a ground, scratched his design through the wax, placed the plates into the nitric acid to produce etched lines in accordance with the design, inked the plate, applied the paper, and put the plate and paper through a press. All this was done on the basis of descriptions contained in the Dutch translation of Noël Chomel's encyclopedia. Kōkan sometimes called these prints "wax plates."

Copper and zinc plates used in etching should have a thickness of 1 to 1.5 mm., but when Denzen used both sides of a plate (see pls. 163–64), he used 2 mm. stock, making a practical adaptation of the bronze mirrors that were readily available in the 1770s and 1780s. Since

149

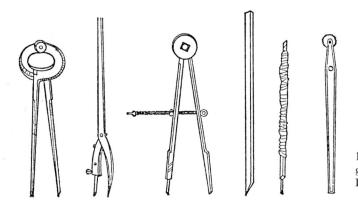

165. Drawing, from a photograph, of tools used by Aōdō Denzen.

the bronze of the mirrors was copper alloyed with tin, it was harder than copperplate, and it is assumed that Denzen resorted to such expedients as adding salt to his etching mordant. His etching *Horse* (pl. 82) shows a certain coarseness of line and imperfection of shading when compared with other works by Denzen, and this is probably due to the problems of working with bronze. Because of this lack of refinement, the Denzen attribution has been questioned, but when the medium is considered, the attribution would appear to be sound. The etching plate is still in existence.

As a matter of technical interest it should also be noted that the native lacquer (with wax and rosin) that Denzen used as an acid-resistant ground for covering etching plates had the necessary qualities of adhering well to the plates while scraping away cleanly without developing cracks when scratched. It was presumably spread with a brush or spatula. The etching needle used by these experimenters, it is said, was tipped with a fish tooth (from a sea bream). Some of Denzen's implements have been preserved (pl. 165), including a compass and a roulette. Early experimenters had trouble with uniformity of acid biting, and Shiba Kōkan probably touched up his plates with dry point techniques. It seems that both Kōkan and Denzen

 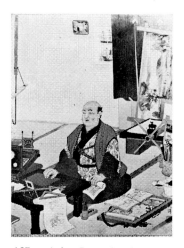

166. *Artist's Studio*, by Shiba Kōkan. Copperplate etching. H. 12.5, w. 9.6 cm. Kobe City Museum of Namban Art.

167. *Aōdō Denzen's Studio*, by Tenyō. Colors on paper. Approx. h. 70, w. 63 cm. Sukagawa Museum, Fukushima Prefecture.

used etching presses made of wood. Among Kōkan's works is a copperplate of an artist's studio (pl. 166), on the right-hand side of which is to be seen a press bed, a vertically operating roller, the wooden frame supporting the press, and in the center an artist, presumably Kōkan himself. The composition suggests that the plate may be based on a Dutch prototype, but it probably also reflects the actual appearance of his studio. A later-day painting of Denzen by the artist Tenyō is also presented for comparison (pl. 167).

Shiba Kōkan gave up his efforts to perfect the techniques of etching without really achieving his goal, but Aōdō Denzen had the zeal and the craftsmanship to pursue this enterprise to its conclusion. He experimented with painting inscriptions and pictorial elements such as clouds on an etched plate with a ground-laden brush for negative or white effects in a second biting, and used his fabric dyeing experience to include indigo and red effects in his printmaking. He and Kōkan liberated themselves from the technical and stylistic confinements of their nation's isolation. Denzen in particular developed an expressionistic freedom of line that is well illustrated in his *Dragons in the Clouds* (pl. 122) and *Violin* (pl. 124). He brought the Edo-period copperplate print to the level of genuine artistic distinction.

151

LIST OF ILLUSTRATIONS IN JAPANESE

153

GLOSSARY

Akita 秋田: the seat of the feudal domain of the house of Satake, in the northwestern part of Honshu, the main island of Japan. The daimyo Satake Shozan was an important interpreter of European art.

bodhisattva: a Buddha-to-be who compassionately refrains from entering nirvana in order to bring salvation to others.

"brocade print." See *nishiki-e*.

bunjin (文人, Ch. *wen-jen*): "Literati." The Japanese genre of *bunjin* painting is derived from Chinese *wen-jen* painting, which was based on the ideal of a man of letters who expressed himself in ink paintings that were intuitive and "amateur" in nature rather than polished and professional. Taking root in Japan in the eighteenth century, *bunjin* painting developed into an important school in the eighteenth and nineteenth centuries, attracting men of diverse background who were alike, however, in their independence of mind and aesthetic principles.

chiaroscuro: the light and dark shading of objects in a picture to show the incidence of light and to create an effect of representational realism.

Ch'ing dynasty: the dynasty that governed China from about 1644 to 1912, which is roughly contemporaneous with Japan's Edo period (1600–1867). The penetration of European art styles that occurred in China at this time was often transmitted to Japan through Chinese works, as in the case of the Soochow print.

Chion-in 知恩院: the Kyoto headquarters of the Pure Land sect of Buddhism. This temple was an important patron of the arts in the Edo period.

colophon (J. 奥付 *okuzuke*): a postscript added to a book, manuscript or handscroll, usually providing identifying information.

daimyō 大名: a "great name" or feudal lord owning extensive lands. In the Edo period there were between two and three hundred such domains.

Deshima 出島: the artificial island built to keep Dutch traders contained in Nagasaki harbor. Deshima was thus the spot from which most European science and art was disseminated during the Edo period.

"Dutch studies" (J. 蘭学 *rangaku*): Dutch studies or Dutch learning—the study of Western civilization from sources written in Dutch.

Edo 江戸: the original name of present-day Tokyo.

Edo period 江戸時代 (1600–1867): The period dominated by the Tokugawa family, who based their operations in the administrative capital of Edo (modern Tokyo). The Tokugawas enforced rigid seclusion policies which, however, did not prevent the slow penetration of European influences.

Kannon 観音: The bodhisattva of mercy, Avalokiteśvara in Sanskrit.

Kanto 関東: the region surrounding the modern city of Tokyo (formerly Edo).

Kii Peninsula 紀伊半島: the peninsula extending south from the main island of Honshu, and located to the east of the island of Shikoku.

mezzotint: the process that produces varied intermediate tones rather than lines in an etching plate. This technique enhances the production of chiaroscuro effects and thus was a matter of great interest to experimenters like Aōdō Denzen.

Momoyama period 桃山時代 (1573–99): A period of rapid internationalization when

Japanese commercial expansion in Asia was accompanied by extensive European commercial and missionary activity in Japan.

Nagasaki pictures (J. 長崎図 *Nagasaki-zu*): prints depicting the topography of Nagasaki.

Nagasaki prints (J. 長崎版画 *Nagasaki hanga*): block prints in a provincial style produced in Nagasaki, chiefly dealing with the subject of European contacts with Japan.

namban 南蛮: "Southern barbarians." The term was applied to the Portuguese when they first arrived in Japanese waters. It is derived from a traditional Chinese expression.

Nampin school 南蘋派: the school of the Chinese painter Ch'en Nan-p'in 沈南蘋, who came to Nagasaki from China in 1731. His illusionistic realism came to be associated with Western-style painting in the Nagasaki area.

nishiki-e 錦絵: "Brocade print." First produced by the Edo *ukiyo-e* print designer Suzuki Harunobu around 1765, these prints derived their name from their lavish use of multiple-block color printing.

Ōbaku school 黄檗派: the school of painting, chiefly realistic portraiture, based on the work of the artist-monks of the Ōbaku Zen Buddhist sect. Since this style had been influenced by contacts with the Jesuit mission in Peking, it had a Westernizing influence on Japanese painting when it was introduced into the Nagasaki area in the seventeenth century.

rangaku. See "Dutch studies."

"red hair" (J. 紅毛 *kōmō*): a reference to the Dutch and, more broadly, to Western civilization.

rōnin 浪人: masterless samurai.

shōgun 将軍: military ruler of Japan during the feudal period.

Soochow prints: prints using an exaggerated version of European perspective principles produced in the city of Soochow in Kiangsu Province, China. Their importation through Nagasaki had a formative influence on Japanese exaggerated perspective prints of the *uki-e* variety.

"southern barbarian." See *namban*.

Suzuki Harunobu 鈴木春信: the mid-eighteenth century *ukiyo-e* painter and print designer who was selected by a group of print connoisseurs to produce the first set of full-color multiple-block "brocade prints" around 1765.

Tōkaidō 東海道: the coastal highway leading from Edo to Kyoto, subject of a number of pictorial series.

uki-e 浮絵: "floating" or perspective prints whose exaggerated perspective effects were often further emphasized by special viewing devices. Maruyama Ōkyo was perhaps the most notable producer of view-box prints of this sort, and Okumura Masanobu the first one to apply these perspective principles to the designing of Kabuki theater and teahouse depictions of the *ukiyo-e* woodblock tradition.

ukiyo 浮世: the "floating world," a reference to the gay quarter and its culture.

ukiyo-e 浮世絵: prints and paintings of the "floating world," dealing primarily with the Kabuki theater and courtesans of the gay quarter. *Ukiyo-e* were generally thought of as belonging to the native Japanese tradition of art, and early *ukiyo-e* print designers sometimes gave themselves resoundingly nationalistic titles. But the *ukiyo-e* artist Okumura Masanobu experimented with the exaggerated use of Western perspective techniques in his *uki-e*, or "floating" prints, and by the time the great landscapists Hokusai and Hiroshige came into vogue in the nineteenth century the principles of Western-style linear perspective were quite well understood and often used by many *ukiyo-e* artists.

view-box prints (J. 眼鏡絵 *megane-e*): prints designed with exaggerated perspective for the purpose of creating an optical illusion of depth when placed in a viewing device equipped with a lens and sometimes a mirror.

BIBLIOGRAPHY

JAPANESE SOURCES
(selected and annotated by the author)

細野正信「アメリカの司馬江漢」(『古美術』38) 昭和47年 [Hosono, Masanobu. "America's Shiba Kōkan." *Kobijutsu*, no. 38, 1972].

————『司馬江漢』(読売新書 29) 東京 読売新聞社 昭和 49 年 [————. *Shiba Kōkan*. Yomiuri Shinsho, vol. 29. Tokyo: Yomiuri Newspaper, 1974].
Written with special attention to Kōkan's work as a portraitist and with extensive commentary on his cultural environment, the eleven chapters of this book are devoted to such subjects as Kōkan's formative years, stylistic training, and emergence as an artist, all presented from a new vantage point. Because of the series' format, the number of illustrations is limited.

————『亜欧堂田善』(ふくしま文庫 16) 福島中央テレビ 昭和50 年 [————. *Aōdō Denzen*. Fukushima Bunko, vol. 16. Fukushima: Fukushima Central Television, 1975].
A study of the relationship between Shiba Kōkan and his one-time pupil Aōdō Denzen, with a comparison of their personalities and works in the context of the historical transition from the age of Tanuma Okitsugu to that of the reformist Matsudaira Sadanobu.

井上隆明「近世洋画の技法的新資料」(『美術グラフ』) 東京 時の美術社 昭和43 年 [Inoue, Takaaki. "New Data on the Techniques of Early Western-style Painters." *Bijutsu gurafu*. Tokyo: Toki no Bijutsusha, 1968].

板沢武雄『シーボルト』 東京 吉川弘文館 昭和 35 年 [Itazawa, Takeo. *Siebold*. Tokyo: Yoshikawa Kōbunkan, 1960].

菊地貞夫『北斎・富嶽三十六景』 大阪 保育社 昭和 44 年 [Kikuchi, Sadao. *Hokusai's Thirty-six Views of Mount Fuji*. Osaka: Hoikusha, 1969].

古賀十二郎『長崎絵画全史』 東京 北光書房 昭和 19 年 [Koga, Jūjirō. *A Comprehensive History of Nagasaki Pictures*. Tokyo: Hokkō Shoin, 1944].
This book organizes into schools and lineages the Western-style artists of the Nagasaki tradition whose work is generically referred to as *namban* or "southern barbarian" art. Since this was a wartime publication the plates are of very poor quality.

近藤市太郎・楢崎宗重『日本風景版画史論』 東京 アトリエ社 昭和18 年 [Kondō, Ichitarō, and Narazaki, Muneshige. *Studies in the History of the Japanese Landscape Print*. Tokyo: Atoriesha, 1943].
A historical account of the development of the *ukiyo-e* landscape print, centering on works by Hokusai and Hiroshige.

黒田源次『司馬江漢』 東京 東京美術 昭和 47 年 [Kuroda, Genji. *Shiba Kōkan*. Tokyo: Tōkyō Bijutsu, 1972].
A posthumous compilation scrupulously annotated by Naruse Fujio.

黒田正巳『透視法』 東京 美術出版社 昭和40年 [Kuroda, Masami. *Methods of Perspective Drawing.* Tokyo: Bijutsu Shuppansha, 1965].

長崎県『長崎県史史料篇』（第四） 東京 吉川弘文館 昭和40年 [Nagasaki Prefecture. *Archieves of Nagasaki Prefecture.* No. 4. Tokyo: Yoshikawa Kōbunkan, 1965].

This volume is primarily concerned with foreign commerce during the Edo period and related historical materials. It reproduces such documentary materials as a detailed description of Nagasaki trading firms derived from regulatory edicts of 1791, a seven-volume compilation of Nagasaki trade records, and a modern study giving a typical annual cycle of events at Nagasaki with a description of local customs and language peculiarities.

長崎市役所『長崎叢書』（長崎略史上・下） 大正15年 [Nagasaki Municipal Office. *Nagasaki Chronicles.* 1926].

中井宗太郎『司馬江漢』 東京 アトリエ社 昭和17年 [Nakai, Sōtarō. *Shiba Kōkan.* Tokyo: Atoriesha, 1942].

A definitive summary of prewar scholarship on Kōkan, this work is now in need of considerable emendation.

奈良環之助・太田桃介・武塙林太郎『近世の洋画――秋田蘭画』 東京 明治書房 昭和40年 [Nara, Tamanosuke; Ōta, Tōsuke; Takehana, Rintarō. *Early Western-style Painting in Akita.* Tokyo: Meiji Shobō, 1965].

A factual and theoretical analysis of Western-style painting in the Akita domain dealing primarily with the work of Odano Naotake and Satake Shozan. This is an extensively revised edition.

成瀬不二雄『司馬江漢』（日本美術絵画全集 25） 東京 集英社 昭和52年 [Naruse, Fujio. *Shiba Kōkan.* Comprehensive Collection of Japanese Paintings, vol. 25. Tokyo: Shūeisha, 1977].

With fifty-eight color plates, a lavish amount of other illustrative material, an extensive bibliography, a guide to seals and signatures, and commentaries on works, this is the definitive work on the subject, representing a lifetime of scholarly investigation.

西村 貞『長崎版画』（日本版画美術全集 6） 東京 講談社 昭和36年 [Nishimura, Tei. *Nagasaki Prints.* Comprehensive Collection of Japanese Prints, vol. 6. Tokyo: Kōdansha, 1961].

A comprehensive and systematic summation of the history of the Nagasaki print, lavishly illustrated.

野野上慶一『長崎古版画』 東京 三彩社 昭和45年 [Nonogami, Keiichi. *Early Nagasaki Prints.* Tokyo: Sansaisha, 1970].

小川鼎三『解体新書』 東京 中央公論社 昭和43年 [Ogawa, Teizō. *A New Manual of Autopsy.* Tokyo: Chūō Kōronsha, 1968].

小野忠重「江戸時代の油性画材の資料について」（『東京芸術大学美術学部紀要』4） 昭和43年 [Ono, Tadashige. "Concerning Data on the Oil Painting Materials of the Edo Period." *Bulletin of the Art Department at the Tokyo University of Fine Arts,* no. 4. 1968].

―――『江戸の洋画家』 東京 三彩社 昭和43年 [―――. *Western-style Painters of Edo.* Tokyo: Sansaisha, 1968].

A handsomely illustrated compilation, by artistic lineage, of the Western-style artists of the Edo period from Hiraga Gennai and Shiba Kōkan to those active at the time of the Meiji Restoration of 1868. The final chapter deals with Western-style painters in the early years of the Meiji period. The author is known both as a printmaker andas a scholar.

158

坂崎　坦『日本画の精神』東京　東京堂 昭和 17 年 [Sakazaki, Tan. *The Spirit of Japanese Painting.* Tokyo: Tōkyōdō, 1942].

A reprinting of a number of important critical essays on Japanese art with commentary, hence a critique of Japanese art criticism. The author's essay provides the title for the work. Among the historically significant writings reproduced are ones by Kanō Yasunobu, Tosa Mitsuoki, Kanō Einō, Nishikawa Sukenobu, Nakayama Kōyō, Kuwayama Gyokushū, Satake Shozan, Motoori Norinaga, Nakabayashi Chikudō, Tanomura Chikuden, and Watanabe Kazan. A chronology and index are provided.

佐藤直助『西洋文化受容の史的研究』 東京 東京堂　昭和 43 年　[Satō, Naosuke. *A Historical Study of Westernization.* Tokyo: Tōkyōdō, 1968].

A historically oriented theoretical treatise on Japan's ideological transition, currently taking place, from a position in the "Far East" to one in the "Far West." The book deals with the impact of population changes, mass communication, the state of the arts, and the influences of futurism, Christianity, and similar topics.

菅野　陽『銅版画の技法』 東京 美術出版社　昭和 37 年 [Sugano, Yō. *Techniques of Copperplate Printing.* Tokyo: Bijutsu Shuppansha, 1962].

————「司馬江漢の銅版画技法の原典について」（『研究報告』216） 東京　蘭学資料研究会　昭和 43 年 [————. "Concerning Shiba Kōkan's Copperplate Techniques." *Kenkyū hōkoku*, no. 216, 1968. "Dutch Studies" Research Institute].

————『日本銅版画の研究』 東京 美術出版社　昭和 49 年　[————. *Studies in the Japanese Copperplate.* Tokyo: Bijutsu Shuppansha, 1974].

A valuable compendium of technical data on the discoveries and adaptations of experimenters like Kōkan and Denzen, by an author who is also a well-known printmaker.

武塙林太郎・成瀬不二雄「小田野直武と司馬江漢の関係について」（『美術史』70） 昭和 43 年　[Takehana, Rintarō, and Naruse, Fujio. "Concerning the Relationship between Odano Naotake and Shiba Kōkan." *Bijutsu-shi*, no. 70, 1968].

外山卯三郎『日本初期洋画史考』 東京 建設社　昭和 7 年　[Toyama, Usaburō. *Studies in the History of Early Western-style Painting in Japan.* Tokyo: Kensetsusha, 1932].

FURTHER READING
(selected and annotated by the translator)

Boxer, C. R. *Jan Compagnie in Japan, 1600–1817.* 2nd rev. ed. New York: Oxford University Press, 1968.

————. *The Christian Century in Japan, 1549–1650.* Berkeley: University of California Press, 1951. Boxer's works are a scholarly summation of this period of Japanese history from a church-oriented point of view.

French, Calvin L. *Shiba Kōkan: Artist, Innovator, and Pioneer in the Westernization of Japan.* Tokyo and New York: Weatherhill, 1974.

An authoritative and illuminating study of the multifaceted genius.

Goodman, Grant K. *The Dutch Impact on Japan, 1650–1853.* Leiden: Brill, 1967.

An informative historical appraisal of Dutch influences during Japan's age of seclusion.

Hall, John Whitney. *Tanuma Okitsugu*. Cambridge: Harvard University Press, 1955.

A revisionist view of unsuccessful attempts at modernization in eighteenth-century Japan.

Keene, Donald. *The Japanese Discovery of Europe, 1720–1830*. Rev. ed. Stanford: Stanford University Press, 1969.

An extremely readable account of the impact of Western learning on certain Japanese intellectuals.

Norman, E. H. *Japan's Emergence as a Modern State*. New York: Institute of Pacific Relations, 1946.

A notable analysis of Japan's rapid and spectacular modernization.

Sansom, G. B. *The Western World and Japan*. London: Cresset Press, 1950.

The classic historical account of Japan's foreign relations in recent centuries.

Sheldon, Charles David. *The Rise of the Merchant Class in Tokugawa Japan*. Locust Valley, N.Y.: Augustin Press, 1958.

A scholarly survey based on multiple and varied Japanese sources.

Szczesniak, Boleslaw. "The Penetration of the Copernican Theory into Feudal Japan." *Journal of the Royal Asiatic Society*. London (April 1944): 52–61.

A specialized but illuminating study of the curious forms an intellectual revolution can assume in highly divergent societies.

INDEX